CW00820159

CIRENCESTER PUBS
THROUGH TIME
Philip Griffiths

AMBERLEY PUBLISHING

To Joyce and Carol, for their loving support in all my endeavours

First published 2013

Amberley Publishing
The Hill, Stroud, Gloucestershire, GL5 4EP
www.amberley-books.com

Copyright © Philip Griffiths, 2013

The right of Philip Griffiths to be identified as the
Author of this work has been asserted in accordance with
the Copyrights, Designs and Patents Act 1988.

ISBN 978 1 4456 1706 0 (print)
ISBN 978 1 4456 1715 2 (ebook)

All rights reserved. No part of this book may be reprinted
or reproduced or utilised in any form or by any electronic,
mechanical or other means, now known or hereafter
invented, including photocopying and recording, or in
any information storage or retrieval system, without the
permission in writing from the Publishers.

British Library Cataloguing in Publication Data.
A catalogue record for this book is available from the
British Library.

Typesetting by Amberley Publishing.
Printed in Great Britain.

Introduction

This is not a pub crawl. We are now encouraged to drink responsibly, but, with this volume clutched in one hand, this walking tour will lead you through the streets of Cirencester to open doors and, if timing and inclination gel, please enter and support the survivors while raising a glass to those pubs that have called last orders.

There are those pubs and inns which exist in documents and deeds but their precise location is not known – unless you know differently and can help locate the missing! The losses can be judged by study of a document preserved in the Gloucestershire Archives dated *c.* 1800 listing seventy-three pubs in the seven wards of the town. Of these, forty-one are reported as 'suppressed' at that date. No reason is given, but the justices of the peace must have considered that Cirencester had a sufficiency of ale and beer retailers. A loss of income for all concerned, but perhaps rowdy behaviour and drunkenness were stronger social issues.

Over the centuries the number of pubs has fluctuated. The Alehouse Recognizance of 1755 lists the names of fifty-three victuallers who were licensed to sell beer. An increase to seventy-three in *c.* 1800 with forty-one suppressed brought the total down to thirty-two, comparable with the number open in 1964. Local directories are a useful source for detail and the 1820 publication by Gell & Bradshaw draws a distinction between inns (seven), and taverns and public houses (twenty-eight). Before the opening of the Great Western Railway in 1841, travel by coach and on horseback demanded adequate stabling provided by inns such as the Booth Hall, Crown, Fleece, King's Head, Ram, Swan, and White Hart.

Brewing in the eighteenth and early nineteenth centuries was a very local process and hop merchants and coopers supported the maltsters and brewers in the town. Much of the beer and ale brewed only travelled the length of the burgage plot before consumption, and 'home' brewing for sale was often a secondary occupation or undertaken by the wife of the licensee. In 1820 Robert Haviland in Dyer Street was the sole distiller in the town, while a directory of 1784 included three wine merchants. Three families – Masters, Cripps and Bowly – developed their own breweries in the town before takeovers by the larger national brewing conglomerates. Malting in Cricklade Street ceased in 1980.

What's in a name? The earliest names recorded from 1540 include Angell, Antelopp, Bell, Bere, Crowne, Hartished, Katheryn Whele, Kings Head, Lyon, Pound of Candles,

Ramme, Swan and Talbott. The last illustrates a note of caution. Today's Talbot in Victoria Road is firmly Victorian in date. Its earlier medieval namesake was in Park Street. Reuse or change of name can lead to confusion.

Pub names are often related to trades, animals and birds, or historical and royal connections and are a fascinating study in themselves. For the survivors, this book will reveal their locations. Those lost, or of which little is known, include the Bush & Candles, the bush being a common symbol to indicate a drinking house. Trades were represented by the Butchers, Farriers, Masons, Plasterers, Slatters, Stonemasons and Waggoners, who have all supplied their Arms, while Horse & Groom, Plough, Pot of Four Combers and Three Tuns hint at other professions and trades.

Birds, animals and fish were represented by the Black Spread Eagle, Crow, Pelican, Black Dog, Fox, Greyhound, Hare, Hart's Head, Lamb, Lion, Three Cats Heads, White Horse, and Salmon.

To complete the list, the precise location of the following remains a mystery: Angel & Lamb, Bowling Green, Bridwell, Catharine Wheel, Chequers, Conduit, Crown & Thistle, George, Green Man, Halfe Moon, Jacob's Well, Mitre, New Conduit, New Inn, Pound of Candles, Seven Stars and the Three Bottles Tavern. Now that would have been a pub crawl!

The saddest losses are those still fresh in the memory. Since 2000 the Royal Oak, Woodbine, White Lion, Queen's Head, Foresters' Arms and King's Head have closed, all converted to private houses except for the last, which is desperately seeking a knight to refresh its market face.

Delving into deeds and documents has been rewarding and frustrating. The wills and inventories of inn-holders in the seventeenth century illustrate the outlay and cost involved. The inventory for William Barker in June 1677 listed six hogsheads and a half with 'bear' in them, four hogsheads empty and three small barrels. His brewhouse contained a brewing furnace, malt mill and one leaden pipe. A hogshead was a 54-gallon cask, so this must have been quite an undertaking. Do you have deeds for William Barker that would help to pinpoint his brewhouse? Much remains to be researched – please help fill the glass.

Philip Griffiths

Gloucester Street
Royal Oak
Duke of York
Nelson
Anchor
Loyal Volunteer
White Lion
Dollar Street
Red Lion
Thomas Street
Hole in the Wall
Cecily Hill
Dolphin

Coxwell Street
Flying Dutchman
Park Street
Phoenix
Black Jack Street
Golden Cross
West Market Place
Crown
Swan
Ram
Ram Tap, Castle Street

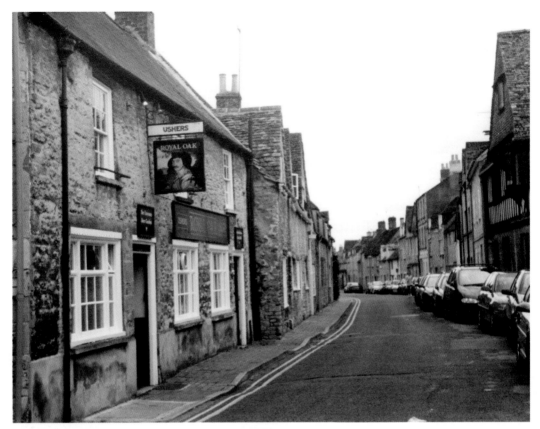

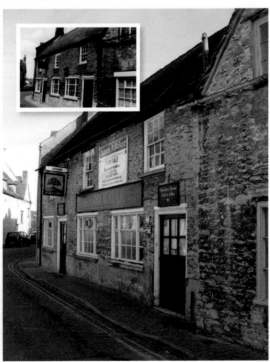

Royal Oak, Gloucester Street

From Castle to Oak to Royal Oak, a change of name would not have deterred the traveller arriving at the top of Gloucester Street after a long journey across the Cotswolds. Changing ownership, however, from Cirencester Brewery, to Courage, to Ushers, to free house could not prevent closure. The Royal Oak finally ceased trading in 2009 and is now a private house. One of its longest serving landlords was Job Sheppard, who retired in 1948 after fifty years on duty behind a bar that had provided food and ale for over two hundred years.

Duke of York, Gloucester Street

The empty bracket on the building far left helps to date this view of Gloucester Street looking south towards the church tower. The Duke of York Inn closed in September 1927 and was sold in 1936 for £444 as a private house. The report to the Cirencester Licensing Session in 1926 stated 'the structure was fair. The trade very good ... police supervision was easy and the management good. There were seven other licensed houses within a radius of 269 yards; these being the Royal Oak, the Nelson, the Anchor, Lamb Brewery off-licence, the Volunteer, the White Lion and the Red Lion.' On behalf of the police, Superintendent Price said the house was largely used by people at the common lodging house opposite, 'not a very desirable class of customer'. In appealing against the closure, Mrs Jane Glass, wife of the licensee Jonah Glass who had held the licence for twenty-three years, stated that there had been no complaint with the management and that the inn was used largely as an outdoor house. The profits formed a great part of their livelihood. Despite good reports the Licensing Authority refused to renew the licence. Previous landlords in the 1850s and 1870s, John Hawker, Edward Merchant and T. Lapper, had supplemented their income by dealing in coal and wood.

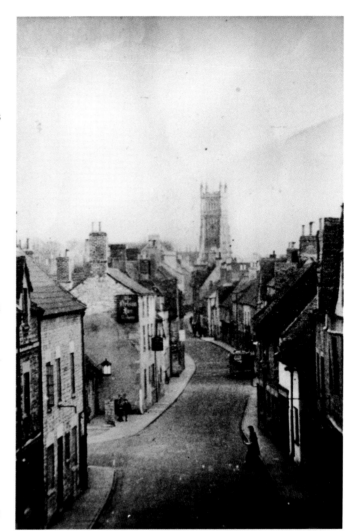

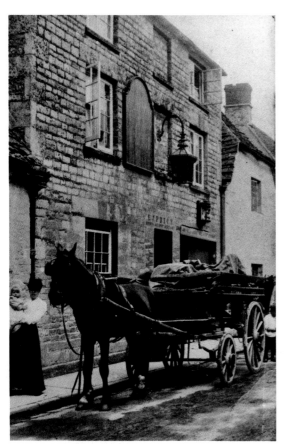

Nelson, Gloucester Street

Just beyond the junction with Gooseacre Lane, the Nelson Inn was in a good position to attract custom from travellers on the old Cheltenham road via Bowling Green Lane, Baunton and North Cerney before the turnpike road was opened in 1825. As a 'Home-Brewing Brewery' for over a century, Edmund John Price continued the tradition until the 1930s. Access to the brewery at the rear was via a passage to the right of the door, now part of the bar. In 1936 Ushers Brewery took control, to be followed by Whitbreads. Today the Nelson is a free house.

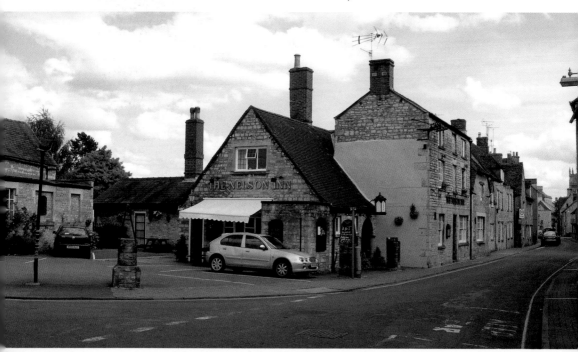

Established Over a Century.

E. J. PRICE

:: "The Nelson" ::

Home·Brewing Brewery

CIRENCESTER,

Is still brewing Pure Home-brewed Beer. These fine Ales are used and reccommended by the Leading Medical Practitioners throughout the District as a Pure and Wholesome Beverage.

Fine Old Cognac Brandies. John Jameson and Dunville's Fine Old Irish Whiskeys. Islay, Old Malt and Edinburgh Whiskeys Sir Robert Burnett's Fine Old London Gin. Coates' Original Plymouth Gin.

Families supplied with Casks of 4½ gallons and upwards.
All Empties will be charged for unless returned in good condition within six months.

PRICE LISTS ON APPLICATION.

Nelson, Gloucester Street
'These fine Ales are used and recommended by the Leading Medical Practitioners throughout the District as a Pure and Wholesome Beverage.' Would such an endorsement be permitted today? Moderation and units of alcohol consumed now guide our drinking habits. E. J. Price offered home delivery of casks of 4½ gallons and upwards – to be consumed within six months!

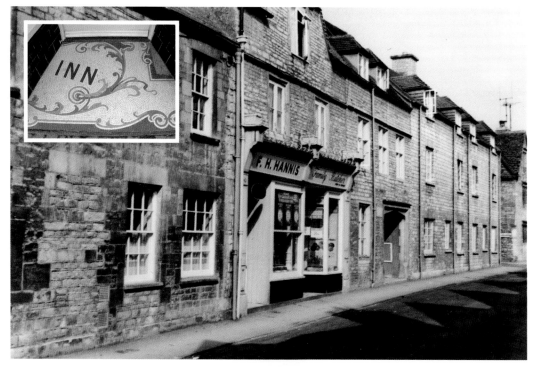

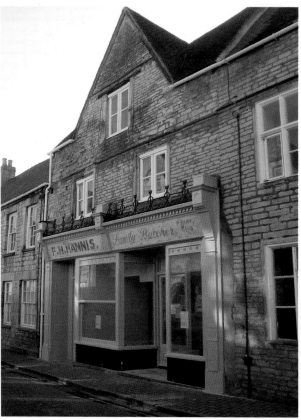

Anchor, Gloucester Street
Many will remember this as
F. H. Hannis' butcher's shop
with the intriguing mosaic floor
inlay of 'Inn' at the entrance.
The will of Thomas Doudin in
1782 describing him as victualler
and renovations in 2011 confirm
this as the Anchor Inn. A
free public house, a 'For Sale'
notice in November 1863 listed
the amenities of 'a large and
lucrative business' and included
parlour, bar, kitchen, cellar, large
Club-room and four bedrooms.
'Annexed is a Cottage, Stable and
Covered Skittle Alley, formerly
the Anchor Brewery.' A choice
of beer is important, and from
1891 the Anchor was the only
pub to be supplied by Richard
Bowly's North Wilts Brewery
from Swindon. Threatened with
closure in 1926, a petition signed
by 345 enthusiasts failed to save
the inn.

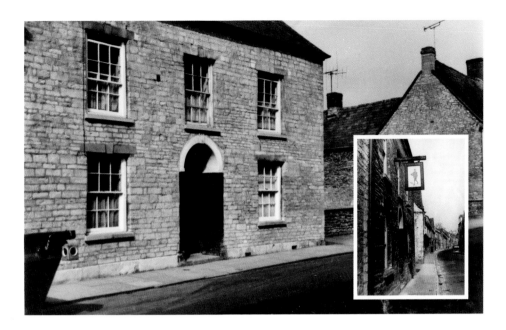

Loyal Volunteer, Gloucester Street

The plain façade conceals the vibrant history, part theatre and part public house, of the (Loyal) Volunteer. The theatre to the rear was built by John Boles Watson and opened in 1799. Visitors and actors have included Sarah Siddons, Edmund Kean and William Cobbett. Once a thriving venue, by 1842 the theatre was being used as a barrel store and the pit as a bowling alley. A serious fire in the 1930s destroyed much of the interior and the pub's closure came in 1955. A private house, the only hint now of its former life is the stub end of the wooden hanging sign.

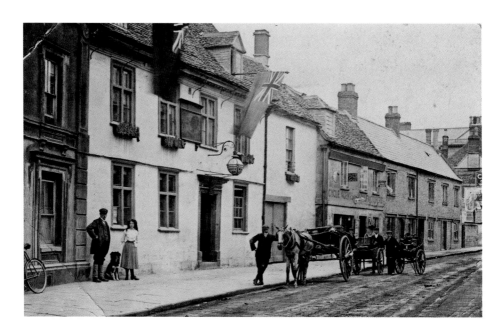

White Lion, Gloucester Street

Two long-serving landlords, Frederick Pace and Edward Moreton, kept pace with the changing modes of transport. The White Lion was a popular venue for village carriers travelling to Elkstone, Brimpsfield, Syde and Cheltenham, while cyclists and private motorists exploring the Cotswolds found a welcoming venue. H. & G. Simonds of Reading supplied the beer in 1937, but it was a free house by 2008 when it closed. The late seventeenth-century building is converted now to private dwellings. The nearby Corinium Court Hotel satisfies the needs of both locals and visitors for drink and accommodation.

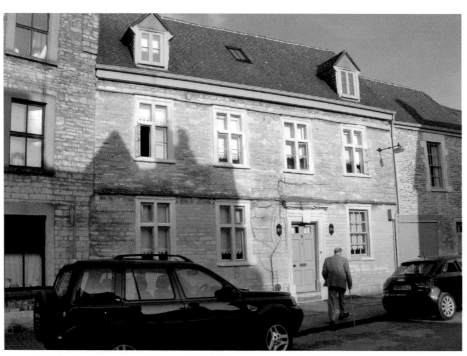

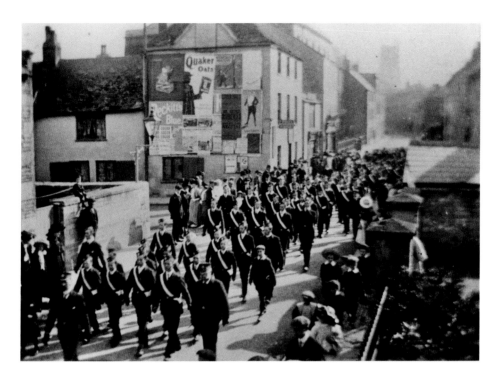

Red Lion, Dollar Street

Standing at the junction with Spitalgate Lane, the side of the Red Lion was bill poster heaven. The Victorian marching band and crowds mask the plain façade of the building, which is now an accountants' office. An alehouse from at least 1800, the Cirencester Brewery owned tavern was run for over eighty years by successive landlords Charles Stallard and James Francis, until the outbreak of the Second World War. Scrap and general merchants businesses supplemented their income, and Stallard was contractor for the Royal Mail cart, which went to Swindon and Kemble.

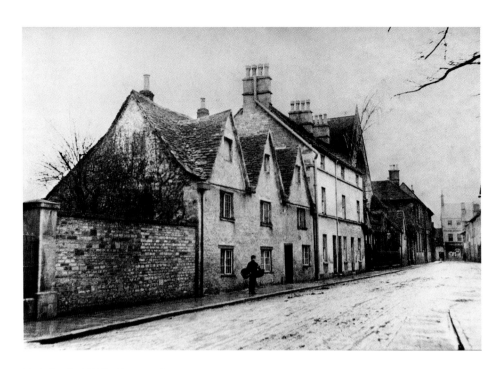

Hole in the Wall, Thomas Street

First recorded on Richard Hall's town plan of 1795, the Hole in the Wall had changed its trading name to the Horse & Groom by 1823. Owned by the Masters family, they sold their brewery and the public house in 1845. The pub became a private house and was demolished in the 1890s by Mr Wilfred Cripps when he extended Mead House to create his own private museum of Roman antiquities. The site of the Masters Brewery was bought by Christopher Bowly, a keen supporter of the temperance movement who paid for the building of the Temperance Hall, opened in 1846 and used today by the Salvation Army.

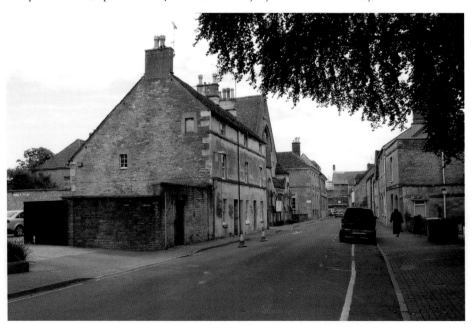

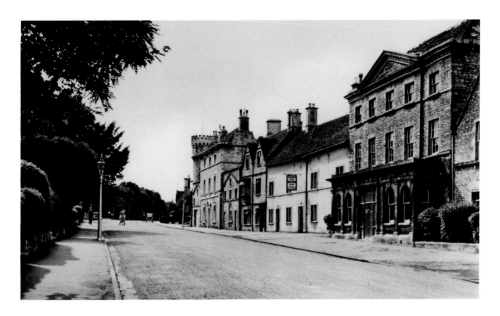

Dolphin, Cecily Hill

Now a gracious approach to Cirencester Park, Cecily Hill was once the main road to Stroud and Bisley via Park Corner, and the Dolphin would have enjoyed brisk trade before 1814 when the Bathurst family diverted the road to its present route. William Folkes, the landlord in 1820, was a victualler serving food, but by 1850 the Dolphin was merely a beerhouse. Frederick Townsend was still pulling pints in the 1930s but now all that remains is the name and the bracket for the hanging sign. One story I was told, and which I would like to think is true, was that the canal feeder ran under the property and in hot weather a crate of beer attached to a rope was lowered into the water to keep it cool!

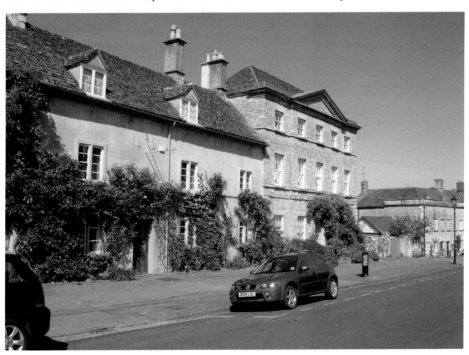

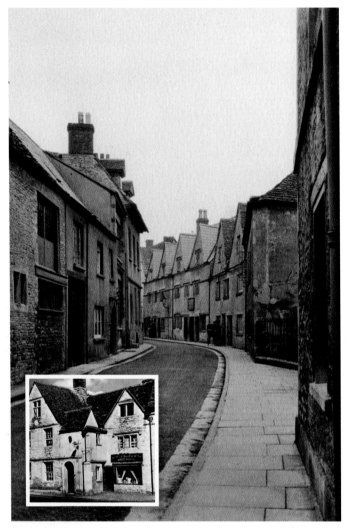

Flying Dutchman, Coxwell Street

James Bishop was the last licensee in 1922. Now a private house, the datestone of 1674 pinpoints the site of the former beer house, which retains internal evidence of its former history. An engraved glass window associates the name with a nautical *Flying Dutchman* rather than the 1849 Derby winner of that name. A Victorian mural announces the rules and prices for skittles. In May 1856 the landlord, Henry Taylor, was accused of allowing illegal gaming to take place on the premises. The case was brought to the attention of the magistrates following an altercation between Mrs Taylor, wife of the landlord, and Mrs King, whose husband was one of those playing a game of bagatelle for beer. Beer brewed on the premises was supplied to Jackson's off-licence in Park Street.

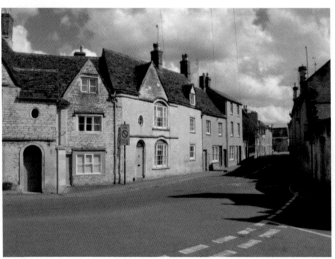

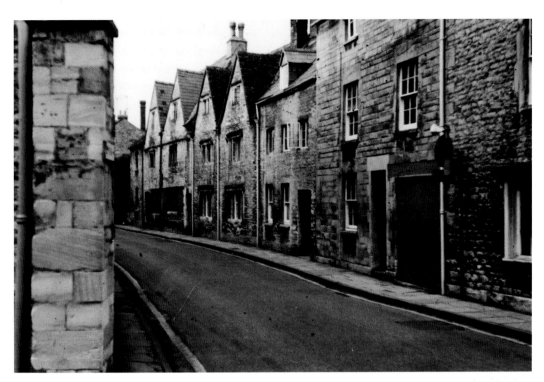

Phoenix, Park Street

Like its near neighbour in Coxwell Street, the Licensing Authority refused the licence renewal of the Phoenix, which was forced to close in 1922 with a compensation payment of £840. A directory of 1820 lists George Meddlecart as landlord of the Phoenix Tavern, which in 1756 had been called the General Wolfe. The change of name was self-fulfilling when in August 1878 a disastrous fire in the neighbouring property left the gap that is still there today. The premises of Henry Mills, cabinetmaker and upholsterer, were totally destroyed despite the best efforts of the fire brigade.

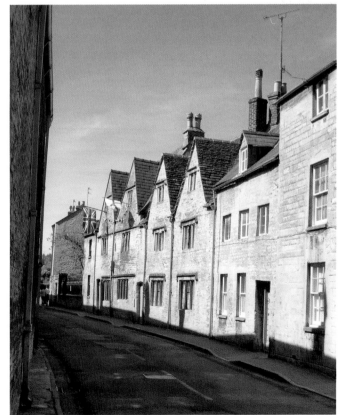

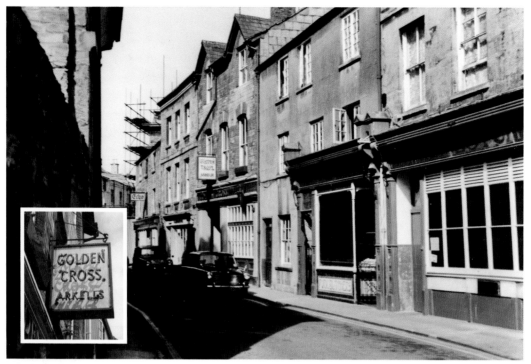

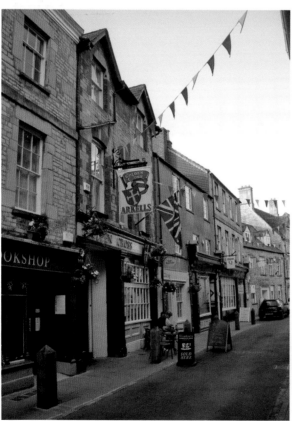

Golden Cross, Black Jack Street
The red and yellow brick façade of the Golden Cross belies its earlier, possibly eighteenth-century, origins. The pub was bought by John Arkell in 1864 and rebuilt in 1874, becoming the first pub in the town to be affiliated to Arkell's Kingsdown Brewery in Stratton St Margaret, Swindon. A document in the company's archives dated to 1826 is the first to name the property as the Golden Cross and to hint at a change of use from private house to licensed premises. The neon sign must have been quite a draw when first illuminated.

Crown, West Market Place

Early advertising cards in the 1940s welcomed visitors to Ye Olde Crown Hotel, guaranteeing an 'Old World yet Homely Atmosphere, modern comforts, electric light, up-to-date sanitation and hot and cold running water and gas fires in every bedroom. Single bedroom and breakfast from 6s 6d.' Bedroom No. 7 had reputedly been used by the future Charles II when escaping in disguise after the Battle of Worcester in 1651. In 1876 the landlord, Charles Radway, described the Crown as an 'Agricultural and Commercial Hotel'.

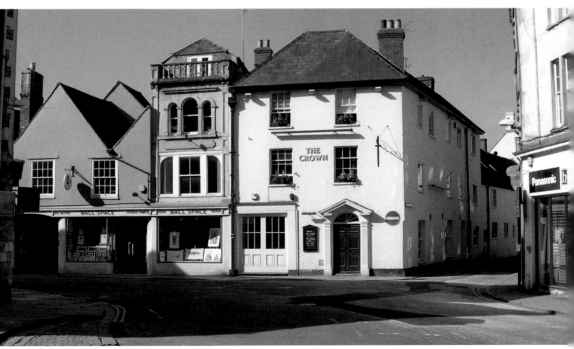

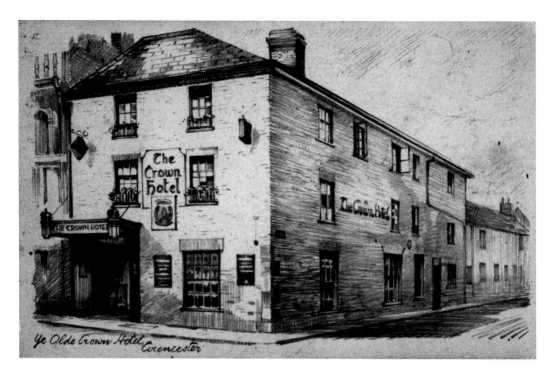

Crown, West Market Place

In the early hours of Sunday 21 June 1914 a disastrous fire destroyed the front of the building. The blaze was first spotted in the bar by passers-by who raised the alarm. The landlord, Mr Quin, and his staff watched as the fire brigade dealt with the fire but by eight o'clock only the servants' quarters, kitchen, upstairs market room, and the stables were left intact. The red brick of the rebuilt Crown is now disguised by a colour wash. The lounge bar has undergone a number of transformations over the years.

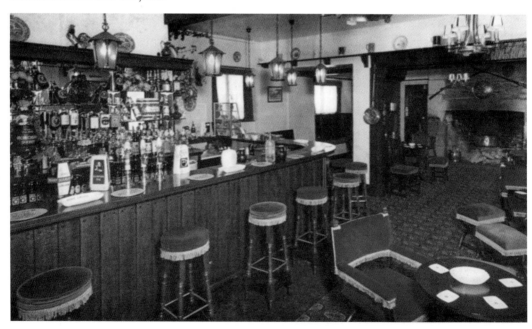

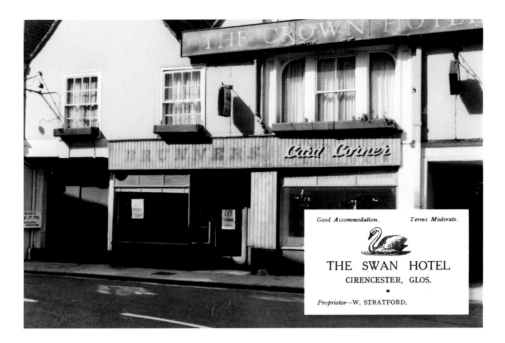

Good Accommodation. Terms Moderate.

THE SWAN HOTEL

CIRENCESTER, GLOS.

•

Proprietor--W. STRATFORD.

Swan, West Market Place

The name first appears in 1540. In a directory for 1792, the Swan, Ram and King's Head were listed as the three principal inns in the town. The premises originally spanned both sides of the entrance to the Swan Yard, the carriage entrance giving access to the stables at the rear. The Nailsworth Brewery Company's Prize Medal Ales and Stouts were available in 1900, with cigars of the choicest brands. Mr Jones, licensee in 1912, offered good accommodation for motorists and cyclists. The Swan closed in 1969.

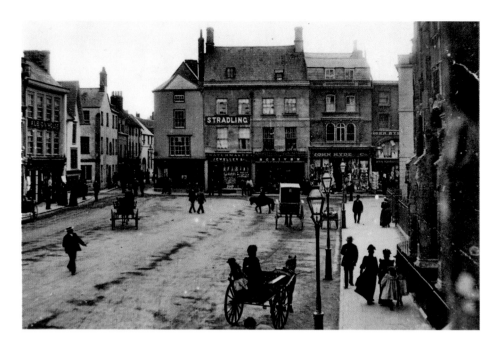

Ram, West Market Place

In its heyday the Ram was arguably the premier coaching inn in the town. The earliest reference is 1547 with a long sequence of landlords extending down to 1894: Shaw, Towse, Tyler, Weaver, Stevens and Stallard. Stagecoaches and the Royal Mail picked up and set down passengers in the West Market Place with coaches leaving regularly for London, Bath and Cheltenham. As coach travel declined in the 1860s, the front of the building was converted into shops. All trace of the galleried courtyard was demolished in 1896 when the north side of Castle Street was rebuilt.

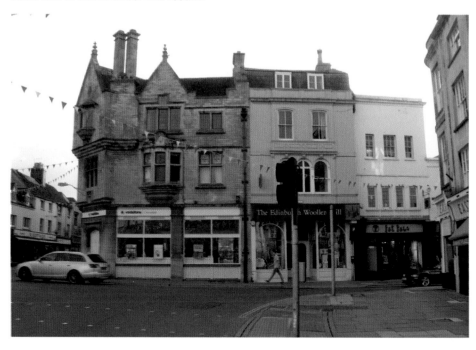

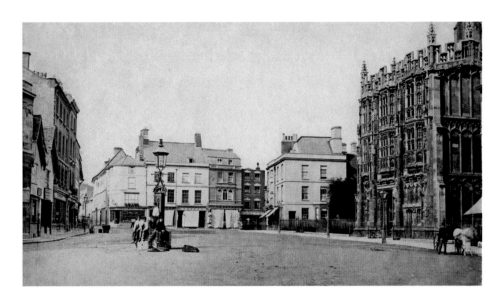

Ram, West Market Place

The sale details for the Ram in July 1863 highlighted the importance of the town as the terminus of a branch of the Great Western Railway, the chief market town in the district, the centre of the Vale of the White Horse Hunt and the headquarters of the Royal Gloucestershire Militia. The hostelry contained a bar, a coffee room and a commercial room, three private sitting rooms, a smoking room, a large market room, fifteen bedrooms, extensive kitchens, underground cellars, stables and loose boxes for thirty horses and lock-up coach houses. The new owners leased the business to the Cirencester Hotel Company, which also managed the King's Head.

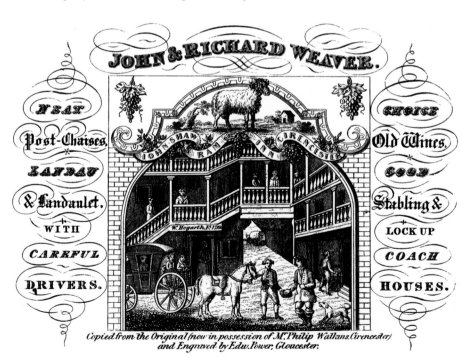

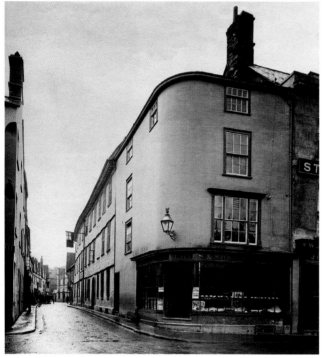

Ram Tap, Castle Street

In addition to the pedestrian entrance from the West Market Place, the Ram Tap sat next to the carriage entrance in Castle Street, the tap being the bar where the servants and labourers were served, while their masters and local gentry were in the inn proper. Richard Jefferies, as a reporter on the local paper, reported on the meetings of the Masonic Lodge and the Cirencester Chamber of Agriculture held in the market room, stories which he fed into *Hodge and His Masters*.

'They live well in Fleeceborough [Jefferies's name for Cirencester] ... they have plentiful food ... And their ale! To the first sight it is not tempting. It is thick, dark, a deep wine colour; a slight aroma arises from it like that which dwells in bonded warehouses ... That dark vinous-looking ale is full of the strength of malt and hops; it is the brandy of the barley. The unwary find their heads curiously queer before they have partaken, as it seems to them, of a couple of glasses. The very spirit and character of Fleeceborough is embodied in the ale; rich, strong, genuine. No one knows what English ale is till he has tried this.'

Market Place (north side)
 Church Tavern
 Packhorse
 Sun
 Fleece
Dyer Street
 Fleece & Bull (I)
 Ship
 Bull (II)
 Bear

Market Place (south side)
 King's Head
 White Hart

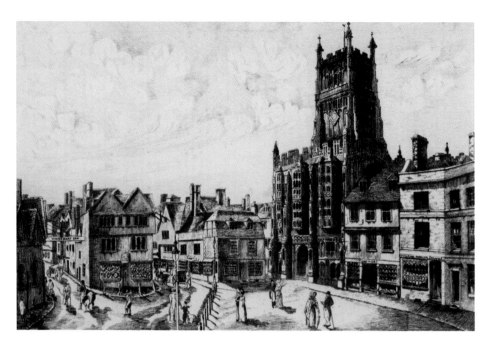

Church Tavern, Market Place

The Town Improvement Act of 1825 authorised the removal of the buildings crowded in front of the parish church. Shops and houses in Butter Row, Butcher Row and Shoe Lane were demolished by 1830. Standing at right angles to the town hall, or south porch, was the Church Tavern. Little is known of its history, but it was not unusual for the church to brew beer for festivals and church ales in order to raise money. This copy by William Brown of an 1805 print by John Evans was used as a calendar in 1910.

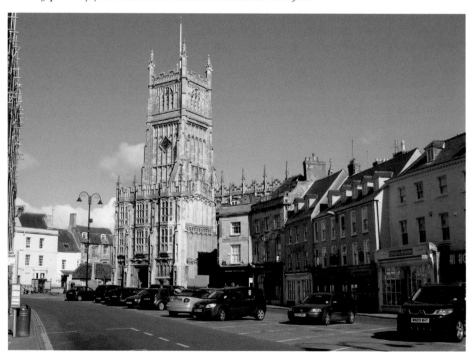

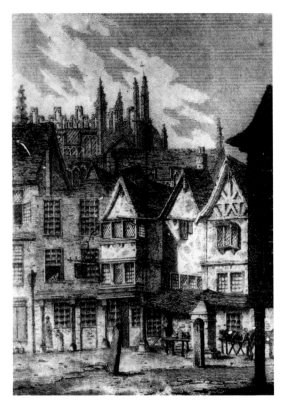

Packhorse, Market Place

Early prints and drawings are often the only sources to help identify the possible location of a former inn. The Packhorse, on the north side of the Market Place, had been suppressed according to the list from around 1800, but perhaps the hanging sign on the print of 1792 offers a clue as to its original site. No other records are known. Strings of packhorses would have been a common sight on the Cotswolds in the medieval period, carrying goods and bales of wool.

Out of sight, below the north parapet of the nave of the parish church, a procession of medieval musicians and revellers enjoy a Whitsun Ale. The stone carvings are now very weathered, but they record the tradition of Church Ales, organised by the church as community fundraisers. The 'ale' refers to the feast rather than the drink, but good stout ale was supplied to help the merrymaking.

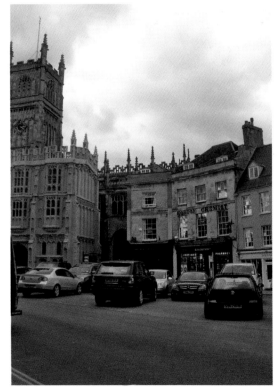

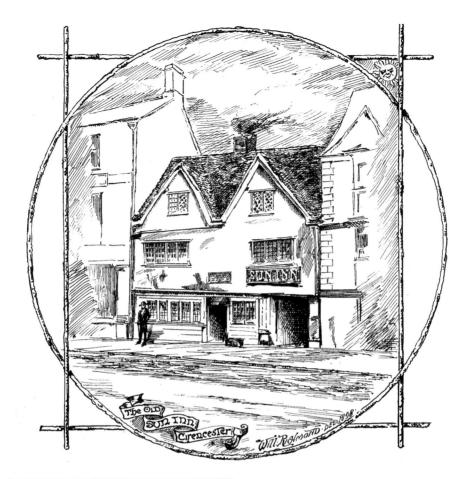

The Old Sun Inn Cirencester

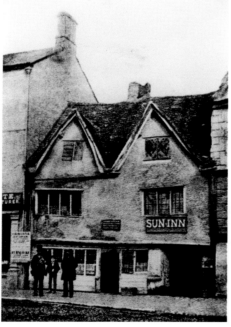

Sun, Market Place

It must have been a tiring case of one-night bed-hopping, for the Sun also claimed a connection to the fugitive Prince Charles, later Charles II, in his escape from the Battle of Worcester in 1651 – a claim assumed by default by the current owners of the Fleece. The Sun is first mentioned in the *Cirencester Flying Post* of 1743, and again in the *Gloucester Journal* for April 1759 which reported: 'To be Lett, The Sun Inn, a good and accustomed house standing extremely well for the market, with stabling for 60 horses.'

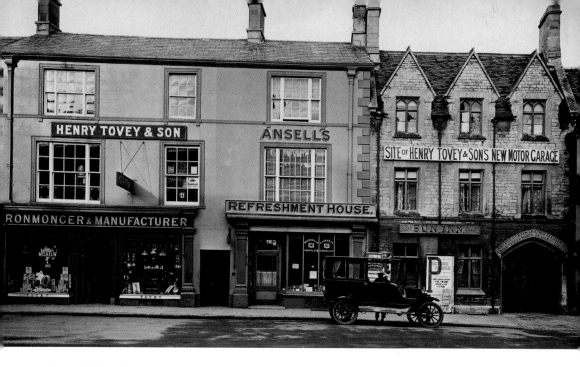

Sun, Market Place

The gabled half-timbered building of the original Sun was rebuilt in 1861 and again in 1913 in a rather more austere Victorian vernacular form, while still retaining the carriage access to the rear, a reflection of its popularity as a stopping off point for local carriers. Mary Ellison, the landlady in 1878, also described herself as a horse letter. The licence was revoked and Walter Cole and E. R. Curtis were the last serving landlords from 1889 to 1922 when it closed.

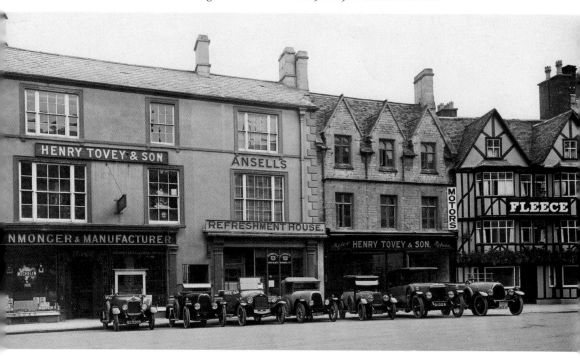

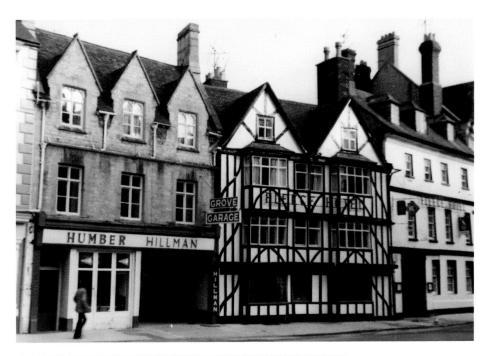

Sun, Market Place
The Sun was bought by Henry Tovey in 1922, no doubt recognising the value of the site. Trading as Grove Garage, the building offered a show window for new cars with extensive workshops to replace the former stables. The petrol pump had an extending arm to reach across the pavement. The garage closed in the 1970s and was refurbished as part of the neighbouring Fleece, creating the ground-floor Corinium Suite used for conferences and functions.

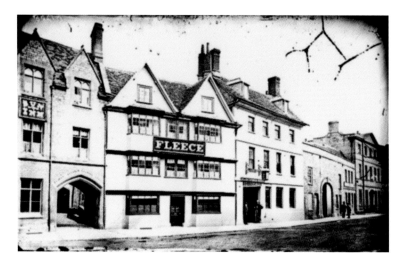

Fleece, Market Place

Until 1800 the Fleece, Bear and Bull competed with one another for the custom of market traders and carriers as Market Place narrowed to Dyer Street, formerly known as Chipping Street. In 1887, local historian Kennett Beecham wrote: 'The Fleece has long been celebrated as an excellent commercial hotel, and has a handsome half-timbered Elizabethan front.' The Fleece in 2013 can claim three period façades: late nineteenth, mid-seventeenth and mid-eighteenth century when viewed from left to right, evidence of its expansion over time.

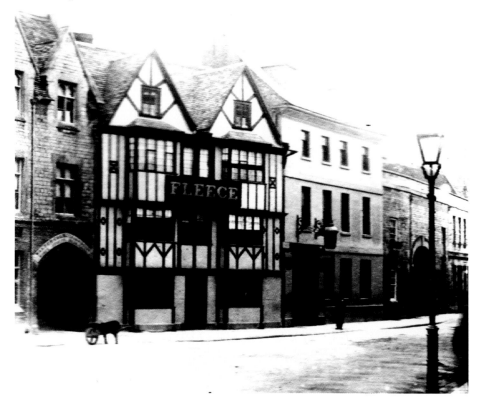

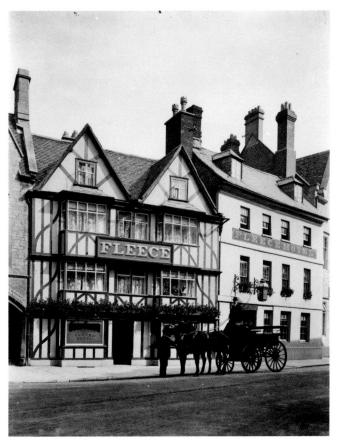

Fleece, Market Place

In a town of Cotswold stone or limewashed buildings, the black-and-white façade of the Fleece has attracted photographers and tourists drawn by its 'half-timbering' which as the postcards show is false – doors and windows come and go as well. In 1982 Trust House Forte painted the mid-eighteenth-century front to match the adjoining centre. 'Hotel in Brush with Planners' ran the newspaper headline, and the paint pots came out again to remove the stripes. Hanging signs and plaques in early views show the hotel's connections with the Cyclist Touring Club and, for car owners, early AA and RAC signs indicated garaging was available.

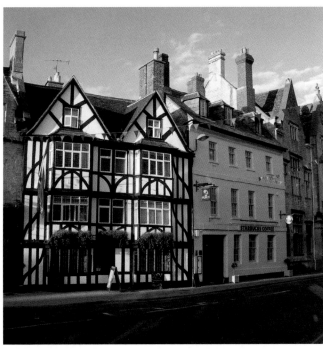

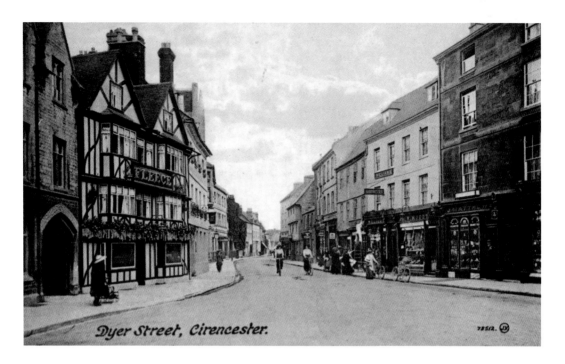

Dyer Street, Cirencester.

Fleece, Market Place

The Fleece vied with the Ram and King's Head to be one of the principal coaching inns in the town. A succession of landlords and managers recorded from the 1750s includes names such as Thomas Leddiard, John Saunders, William Brewer, Charles Hiever, Mary Saunders and John Hayward. By 1830 the Fleece was known as a commercial hotel, an early use of the term 'hotel', and James Trinder, Henry Sare and L. T. Campion continued to supervise the running of an establishment to cater for businessmen, visitors and tourists.

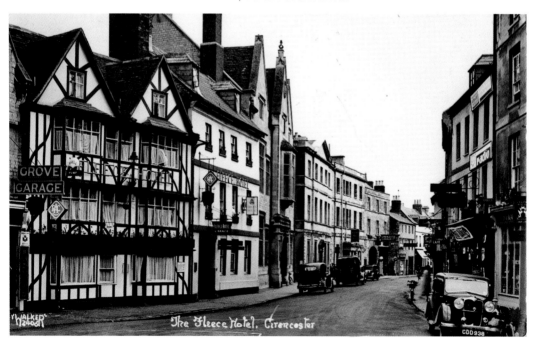

The Fleece Hotel, Cirencester

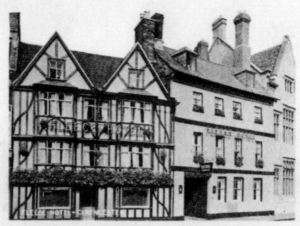

FLEECE HOTEL, CIRENCESTER.
Telephone 127.

TARIFF

	£	s.	d.
Single Bedroom and Breakfast, per night	0	7	6
Double Bedroom and Breakfast, per night	0	15	0
Twin-bedded Room and Breakfast, per night	0	15	0
Sitting Room, per day . . .			
Luncheon . . . 2/6 and	0	3	0
Afternoon Tea	0	1	3
Dinner 3/– and	0	4	0
En Pension Terms, per week . .	3	13	6
(Available for a stay of five days or over)			
EXTRAS. Early Morning Tea . .	0	0	6
Garage overnight . .	0	1	0

En Pension and Week-end Terms must be
claimed when the room is booked.

PROPRIETORS - - TRUST HOUSES LTD.

1933 46

Fleece, Market Place

A 1915 advertisement mentions stabling with posting parties catered for, a free garage, and a bus to meet all trains. By 1927, the hotel was run by County Hotels Ltd. The tariff published in the local town guide for 1933 illustrates the rates charged by the then new owners, Trust Houses Ltd (later the Trust House Forte Group).

CIRENCESTER · F.G LODGE

Fleece, Market Place

In April 2011 the Fleece was taken over by Daniel Thwaites of Thwaites Inns and underwent a major £1 million redevelopment programme. Open fires, the retention of original features and the refurbishment of guest rooms have provided an AA 5* Inn in the centre of town. All-day dining facilities include breakfast served from 7 a.m., while sliding French doors once again open up the ground floor of the former Grove Garage to al fresco dining, with a sheltered courtyard to the rear for those looking for quiet privacy.

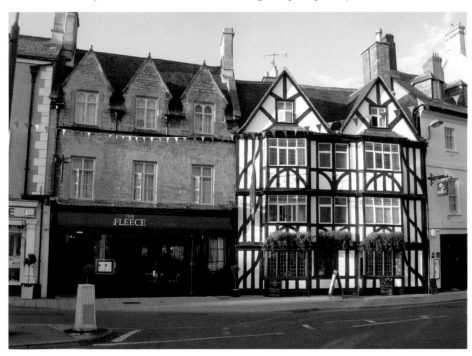

"Fleece Hotel Cirencester. No. 2."

Fleece and Bull (I), Dyer Street

The rear courtyard of the Fleece would have been typical of the access passages to stabling and back lanes, in this case Bull Lane, now the Waterloo. Two Bulls, very confusing, but the first Bull was 'a little below the present Fleece Hotel'. Early records of the Bull Club in the 1780s state that 'whenever ye malt liquor is very bad at ye Bull members went next door to the Fleece or the Old Crowne'. The original Bull was suppressed by around 1800 and had become the private residence and office of Robert Croome, cheese factor.

Bull (I), Dyer Street

In 1903 the site was shared by the parcels office and garage for the Fairford & Cirencester Omnibus Company and Burrows's Corn & Sack Store. The site was cleared and by September 1905 the residents of Cirencester enjoyed 'the Noble Gift' of a public library, 'the munificent benefaction of Daniel George Bingham'. In 1975 the library moved to a new building in the former garden and Bingham House is now an art gallery and offices.

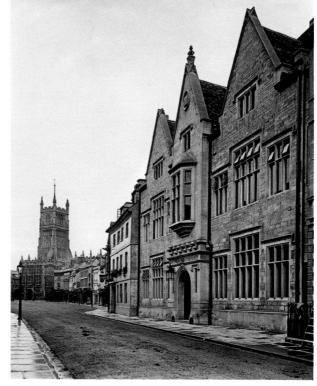

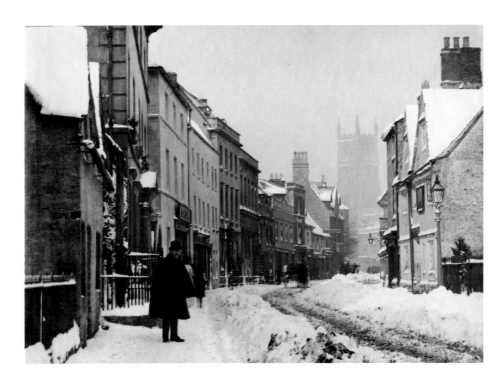

Ship, Dyer Street

Title deeds date from 1784, and Gell & Bradshaw's Directory for 1820 lists 'Mary Tombs, Victualler, The Ship Inn'. By 1822 it was under the control of Messrs. Cripps, Byrch & Co., later Cripps Brewery, with a succession of licensees including Joseph Boulton, first mentioned in 1847. Was his business affected by the roadworks or did he capitalise on the influx of visitors in 1849?

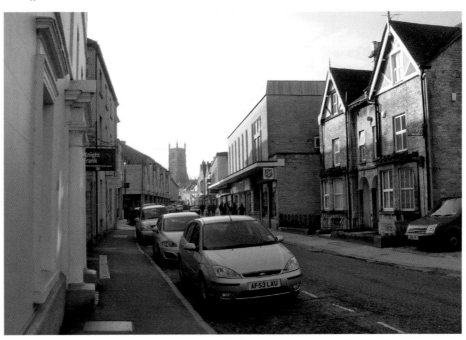

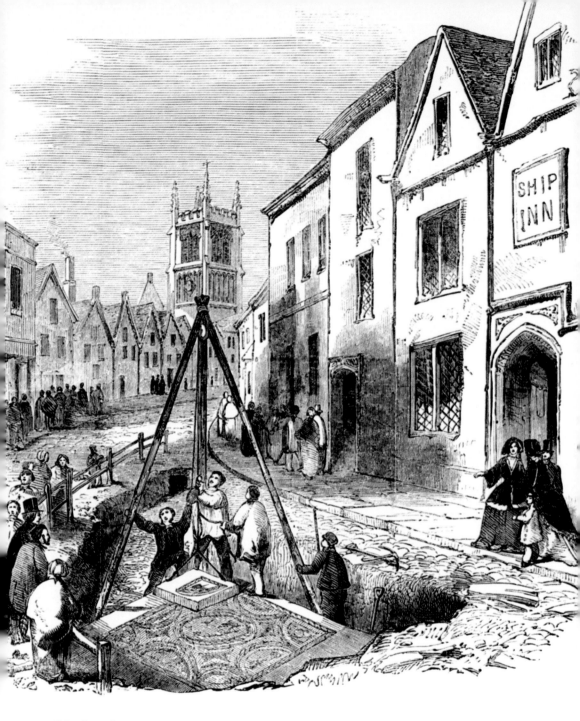

Ship, Dyer Street

The façade of the inn featured in an article in the *London Illustrated News* for 8 September 1849, which reported the discovery and lifting of two Roman mosaics, now displayed in the Corinium Museum in Park Street. The Hunting Dogs and Four Seasons mosaics were originally on show in the Bathurst Museum in Tetbury Road, opened in 1856 on the site of the first Barley Mow. The line of Dyer Street sits obliquely over the *insula* grid of the Roman town.

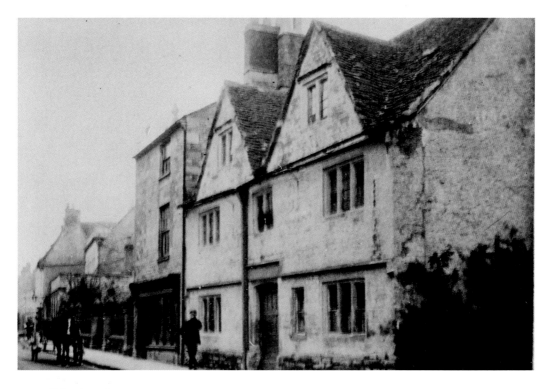

Ship, Dyer Street

The licensing authorities refused an application to renew the licence in 1891 and the Ship had closed by 1897. Demolition followed soon after and the 'fine old building with stone labelled and moulded windows and doorway' was replaced by two villas, now close neighbours to the 1972 redevelopment in reconstituted Cotswold stone. The massive nail-studded oak door bore the carved date 1688.

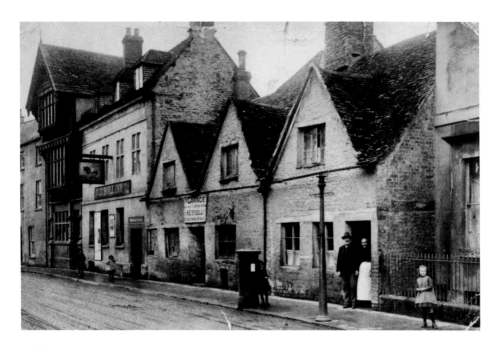

Bull (II), Dyer Street

The Bull relocated to a site further down Dyer Street sometime after 1800. Trade was good but the need to have a second income was always present. An advertisement appeared in the *Wilts & Glos Standard* in July 1866, addressed 'To pleasure parties etc, a large and convenient tent capable of dining 150 persons may be obtained for Pic-nic and other parties at a reasonable charge. Apply to Mr Blackford, The Bull Inn.' In June 1870 a general servant was wanted, 'one who understands cooking'.

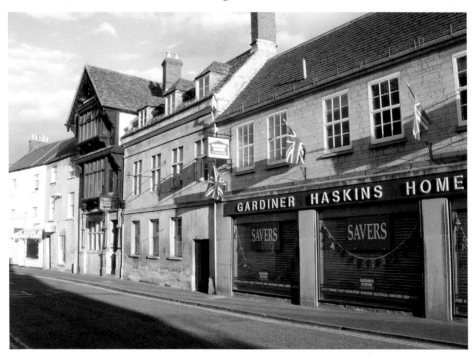

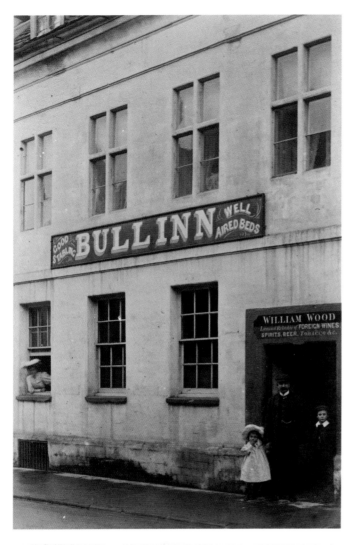

THE BULL INN

DYER STREET CIRENCESTER

Cirencester Brewery Co.'s Ales & Stout
Bass, Worthington, Guinness, etc.
Wines and Spirits—all the best brands
PARTIES CATERED FOR.

Headquarters R.A.O.B. *Skittle Alley*

MOTOR CARS AND COACHES FOR HIRE—
Moderate Terms.

DONALD COLE, *Proprietor.* Phone 94

Bull (II), Dyer Street

In 1910 William Wood was tenant of the Cirencester Brewery-run inn, while Waldron Griffiths leased a building to the rear for his aerated water manufactory. A 1915 valuation lists bar, kitchen, smoke room, small sitting room and wine cellar on the ground floor, with a large club room on the first floor with its own separate approach from the courtyard. Stables, coach house, trap house and skittle alley extended to the rear. In the 1880s, the Bull was a pick-up point for William Smith, carrier for parcels and passengers to Ablington and Barnsley each Wednesday and Friday.

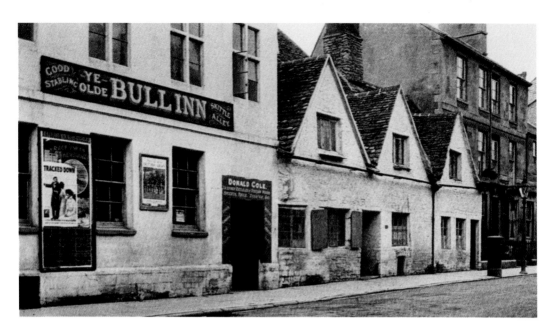

Bull (II), Dyer Street

Donald Cole was a long serving landlord from at least 1912 to 1940, advertising himself as a charabanc and car proprietor. A successful breeder of pigeons, his 'Kenley Lass' was awarded the Dickin Medal in March 1945. The equivalent of an animal VC, the citation reads: 'For being the first pigeon to be used with success for secret communications from an Agent in enemy-occupied France while serving with the National Pigeon Service in October 1940.' Last drinks were served in June 1963, but the bracket for the pub sign survives.

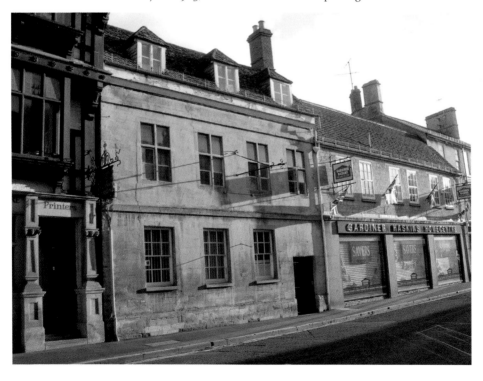

Bear, Dyer Street

The name, *'le Bere'*, first appears in a document dated 1540. One of only a handful of timber-framed buildings to survive in the town, the jettied front suggests a date in the sixteenth century for its construction. Deeds in Gloucestershire Archives date back to 1686, with a reference to the old gaol or bridewell which once stood next to the Bear. The first named licensee was Moreton Austin Hoare in 1809.

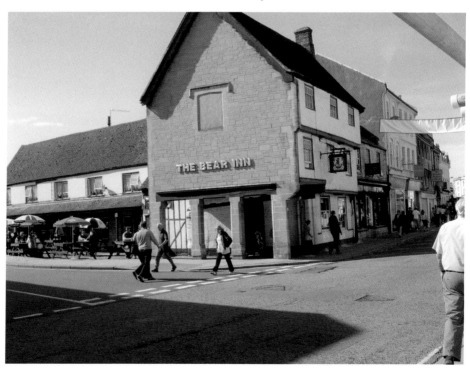

Bear, Dyer Street

The stark side elevation dates from the early 1960s, when North Way was knocked through to create the Forum car park with access to new neighbours including the police station and magistrates' court. Makeovers and upgrading are commonplace and necessary to keep pace with changing fashions and social drinking habits. For the Bear, 2012 was pivotal, with change of owner, brewer and ambience – an outdoor sitting and eating area is an important component, in spite of the British weather.

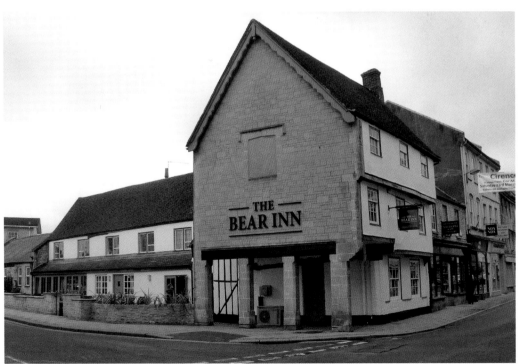

Bear, Dyer Street

Like many old inns, the Bear used to brew its own beer. In 1878, R. Harding advertised home-brewed fine old mild, bitter ales and porter. Previously, from 1847 the Bear had been in the hands of the Woodman family with a close association with Stratton Brewery. In 1873, in an advertisement, 'Ann Woodman respectfully announces that she supplies genuine family ales from 10d a gallon, and good harvest beer from 6d a gallon'. By 1882 William Basil Smith was licensee but with a change in emphasis from brewing alcoholic drink to manufacturing tonic beverages and aerated water.

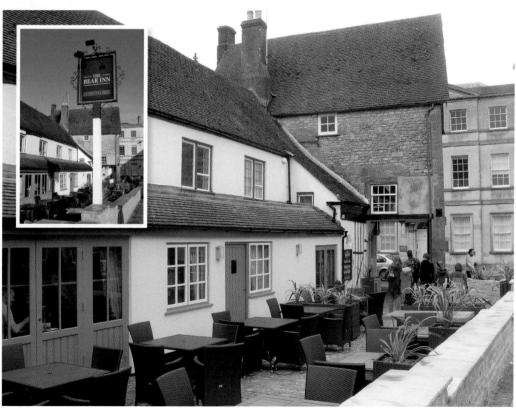

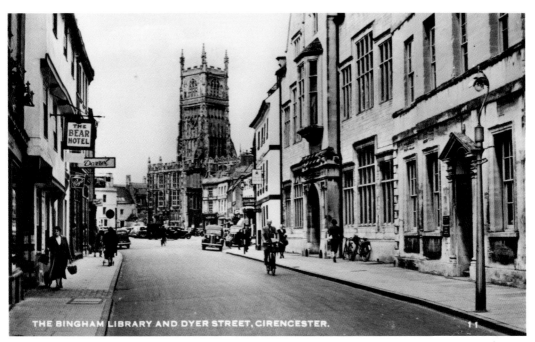

THE BINGHAM LIBRARY AND DYER STREET, CIRENCESTER. 11

Bear, Dyer Street

With a prominent frontage at the bottom of the Market Place, the inn was a popular haunt for farmers and livestock dealers in the days when the twice-weekly market was held in the centre of town, before Earl Bathurst built a state of the art Cattle Market in Tetbury Road, which opened in 1867. Leading Cotswold Ram breeders such as the Garnes, Lanes, Hewers, and Bartons were regular customers at the sheep fairs, as were the local village carriers.

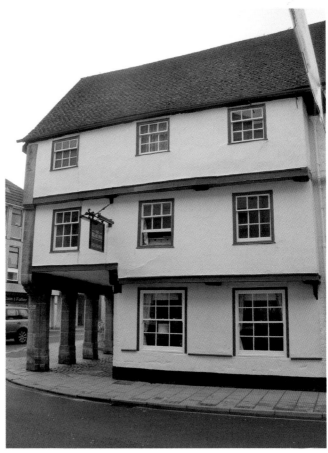

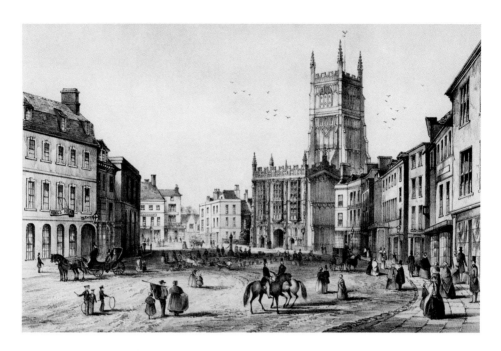

King's Head, Market Place

How old is the King's Head, and which King does it refer to? It features in the royal records of Edward VI (1547–53) and Charles I. The inn sign has always favoured Charles for his association with Lord Chandos and his ill-fated attempt to muster supporters for the King at the beginning of the Civil War in August 1642. Public rooms called the Whitlocke and Lovelace Suites commemorated the fatal attack by Captain Lorenge in 1688, prior to the accession of William and Mary. Documents suggest ownership by the Strange family from 1550 to 1655 at least, including the neighbouring properties of the Antelope and Boothall with a right of way to Cricklade Street.

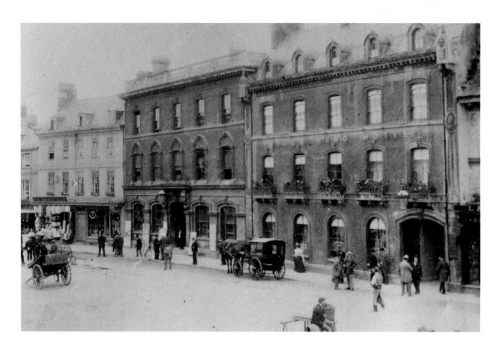

King's Head, Market Place

The inner core may be centuries old, but the coloured stucco façade is 1863/64, built to designs by Medland, Maberley & Medland, who two years previously had built the neighbouring Corn Hall on the site of the Antelope. From 1863 Mrs Nicholas acted as manageress of both the Ram and the King's Head for the Cirencester Hotel Company. Its central location determined its attraction to stage- and mail coaches, providing accommodation for travellers and acting as a pick-up point for parcels and letters.

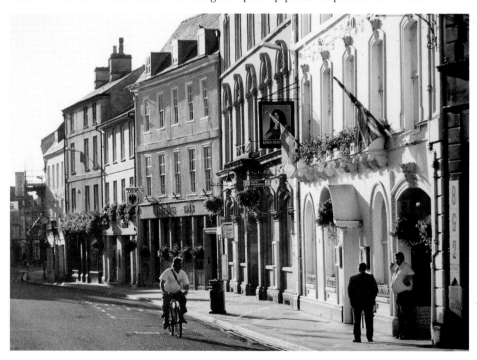

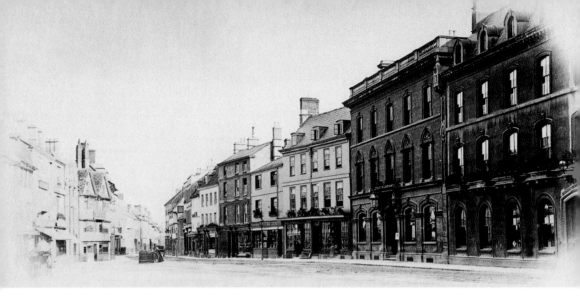

King's Head, Market Place

In 1912 the King's Head proclaimed itself to be the leading family and commercial hotel, with spacious coffee rooms, private sitting rooms and 'with the further distinction of being the first institution in the town to have a fully working installation of the electric light'. The new proprietor, Mr J. T. Brockman, was proud to announce that visitors who previously had to take their own tub in their rooms now had access to three bathrooms. The Georgian assembly room became a much-frequented ballroom hosting private and public dinners and dances, many of the social functions making use of the shared facilities provided by the adjacent Corn Hall.

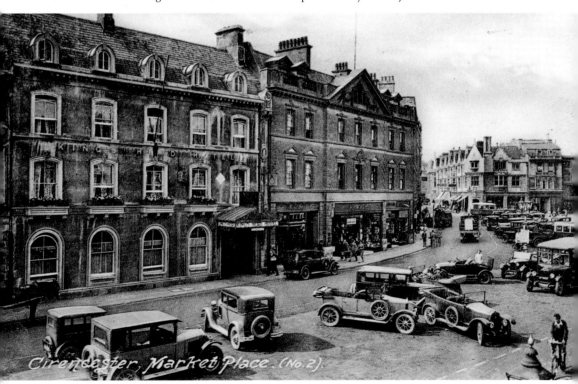

Cirencester, Market Place. (No.2).

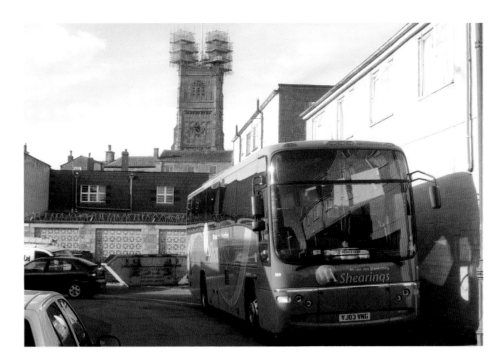

King's Head, Market Place

Excellent stabling, loose boxes for hunters and special terms for the winter season highlight the social status of many of its clientele in the early twentieth century, with the local paper regularly listing the names of those staying at the hotel. Accommodation for maids, valets, and other servants of visitors was provided. As horses gave way to cars, the large motor garage with examination pit and covered yard afforded ample accommodation for cars. During the First World War, to release a man for the Army, Miss Myrtle Newton was employed as the hotel's chauffeur – 'she does all her own repairs'.

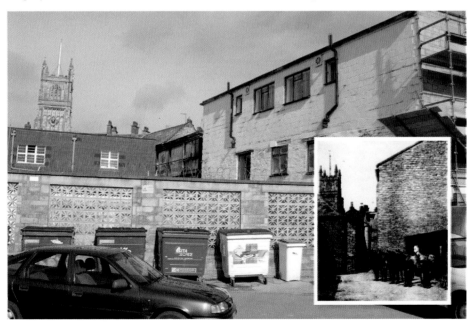

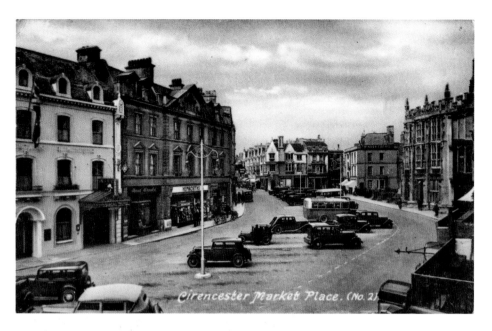

Cirencester Market Place. (No. 2)

King's Head, Market Place

In 1936 Mr Brockman sold the King's Head to a private family company whose chairman was Mr Noel Dean. Michael Haigh-Gannon, as manager for many years, was responsible for introducing themed weekends and Roman tasting menus. The hotel was acquired by Mr and Mrs Bannerman in 1992 who sold to Shearings in July 1997. In 2007 Wildmoor Properties added the Corn Hall to their property portfolio, having acquired the King's Head in 2002. Refurbishment of the Corn Hall was completed in 2008, but sadly the King's Head stands forlorn and shuttered.

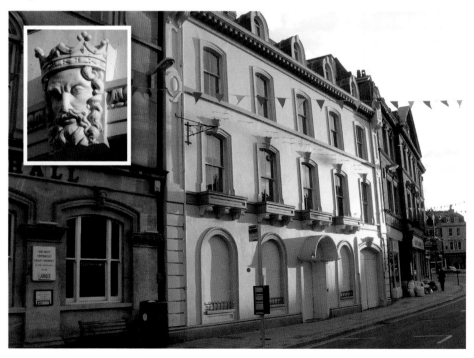

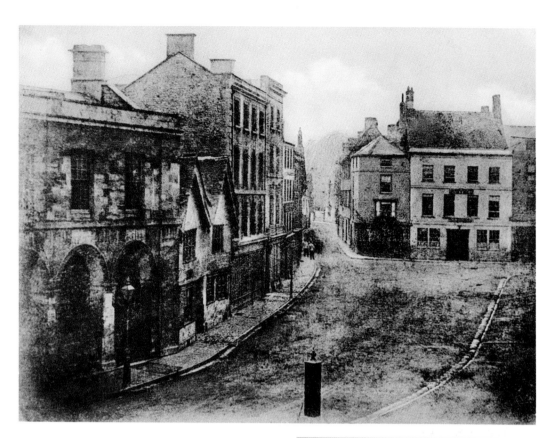

White Hart, Market Place

The twin gables of the White Hart sit
dwarfed by imposing buildings at the head
of the Market Place in one of the earliest
photographs to survive of the town. Believed
to have been built about 1600, the White
Hart was demolished in 1872. The frontage
of 34 feet belied the extensive offices, brew
house, stabling, yard, and gardens that ran
back from the street giving a rear access to
Cricklade Street, as described in the 'For Sale'
notice of March 1855. The triple arches to
the left marked the entrance to the Market
Hall, built by Earl Bathurst in 1819. The store
Cargo now occupies the site of the White
Hart, while the Market Hall made way for the
Wilts & Dorset Bank in 1897.

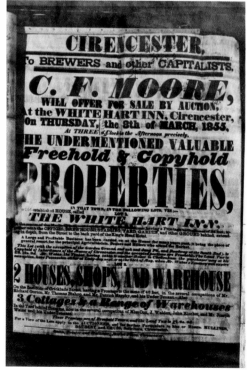

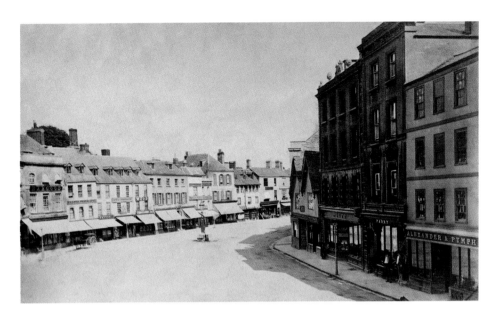

White Hart, Market Place

The White Hart appears to have been freehold throughout its life, with a large and profitable business, 'it being the place of general resort for the principal agriculturalists, dealers and millers who attend the market'. One of the rooms in the new Market Hall was used by the inn as a market room and as a new year treat in January 1861 Wildermans Theatrical Company performed with 'very considerable success'. In the later stages of its life, William Porter kept the licence alive as a wine store, though customers only frequented it in the evenings and on market days.

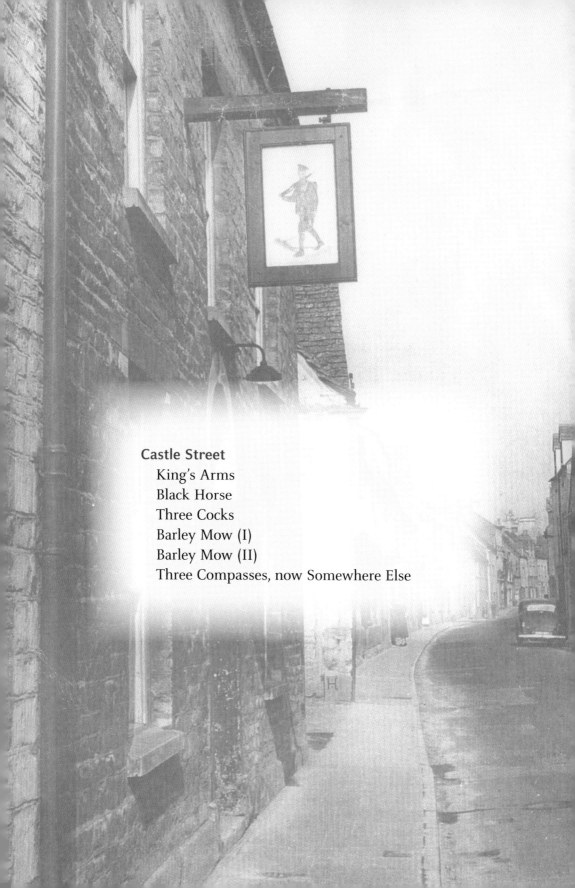

Castle Street
King's Arms
Black Horse
Three Cocks
Barley Mow (I)
Barley Mow (II)
Three Compasses, now Somewhere Else

King's Arms, Castle Street

The earliest record of this establishment is from 1723. Anthony Carpenter was landlord in 1741 and by 1821 Abel Price was described as a victualler, supplying food, drink and accommodation. Henry Court, standing left with his twin brother and Jock the dog, was landlord from October 1911 until 1924 when the King's Arms closed with a balance of £17 12s 6d. The group photograph, opposite, captures the Court family in 1916 with four soldiers, all of whom failed to survive the First World War. For the King's Arms, a brief spell of uncertainty was followed by rebuilding and amalgamation with the neighbouring Black Horse in 1927.

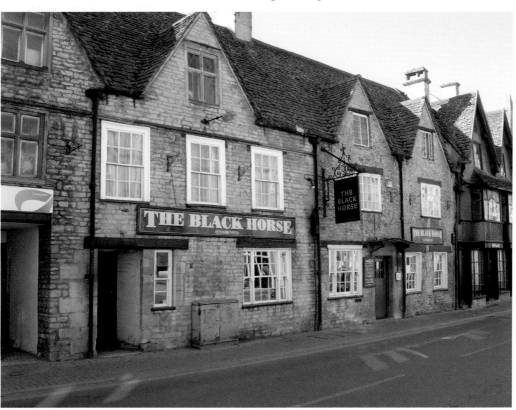

Black Horse, Castle Street

One of the oldest inns in the town, the Black Horse was first mentioned in 1674 and in 1741 was the venue for a meeting to decide upon 'Rules and Orders for a Friendly Society or Ringing Clubb'. As the Black Horse Commercial Hotel from 1927, the landlord, William Thornton, was host to a number of distinguished visitors, including the author Graham Greene who with his brother in June 1932 had walked from Northleach because there was no bus. Always black, the horse has been cart, hunter and polo, or plain text.

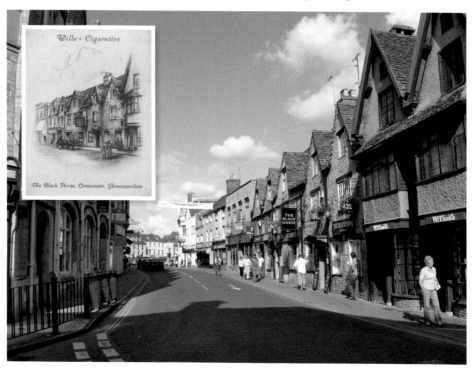

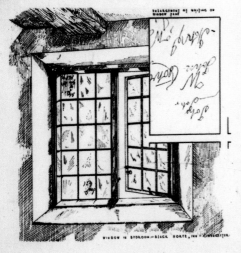

MYSTERY ROOM.

WRITING MYSTERIOUSLY DONE
AT MIDNIGHT ON AUGUST 13th. 1933.

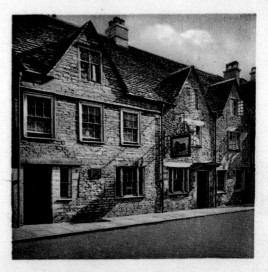

BLACK HORSE HOTEL,
CIRENCESTER, GLOS.

Black Horse, Castle Street

The mystery of a glass pane scratched with letters: 'Writing done at midnight on August 13th 1933' was announced with a scream by Miss Ruby Bower, the terrified occupant of the bedroom when she awoke to the sound of rustling to see the figure of an old woman with an evil expression on her face. Haunted or not, the truth was revealed in 1996 when the *Wilts & Glos Standard* reported the scratches were the work of Jack Court, whose childhood playroom had been in the attic of the King's Arms.

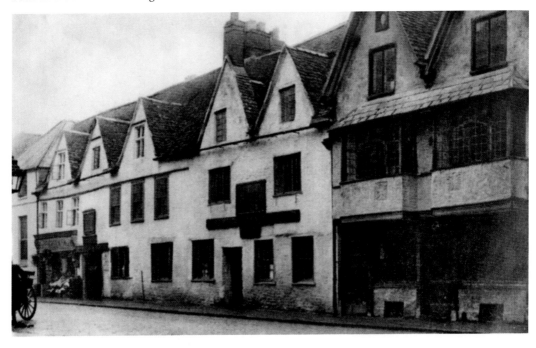

At the THEATRE *in the* Three-cocks Yard, *in* CIRENCESTER,

ON Wednesday Evening, being the 13th of this Inftant June, will be performed a CONCERT of MUSIC. Pit 2s. Gallery 1s.—Between the feveral Parts of the Concert will be prefented, *Gratis*, a Celebrated COMEDY, called

The Provoked Hufband; Or, A Journey to London.

To which will be added a Farce, called Mifs in her Teens.

☞ The kind Applaufe of our Audiences while at GLOUCESTER is an Inftance of their Willingnefs to encourage a *Good, Moral, Theatrical Performance*, when conducted with *Decency* and *Order*; both which being in our Power, our *Spectators* may depend upon our making THEM *our Guides*, as well in our *Private* as our *Public Station*, and that we fhall omit neither *Expence* nor *Induftry* (as far as in us lies) to make the Evening's Entertainment *Rational* and *Agreeable*, and worthy the *Attention* of a *Thinking Audience*.—Our Stay in Cirencefter will be Six Weeks, and (pofitively) no longer; during which, we fhall perform every Monday, Wednefday, and Friday, beginning punctually at Seven o'Clock.—We fhall take Care to have a fufficient Number of Bills delivered, therefore hope the Ceremony of a Drum will be excufed,—During the Races we fhall perform every Night, beginning as foon as the Race is over.

Three Cocks, Castle Street

Old advertisements and deeds can be informative, enlightening and frustrating. The *Gloucester Journal* announced performances at the Theatre in the Three Cocks Yard from Wednesday 13 June 1753: 'Our Stay in Cirencester will be Six Weeks, and (positively) no longer; during which we shall perform every Monday, Wednesday and Friday, beginning punctually at Seven o'Clock. We shall take Care to have a sufficient Number of Bills delivered, therefore hope the Ceremony of a Drum will be excused – During the Races we shall perform every Night, beginning as soon as the Race is over.'

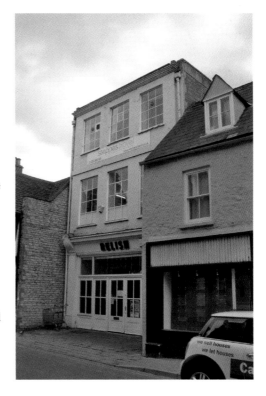

But where was the Three Cocks, alias Seven Stars? The name is first mentioned in 1650. The licence expired in 1904 and the building was demolished to be rebuilt as Farrell's Stores, set back from the line of Castle Street opposite the former magistrates' court.

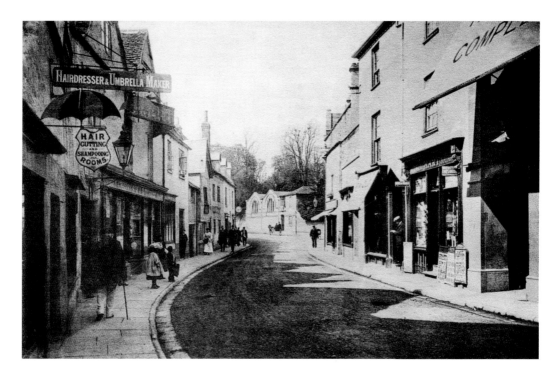

Barley Mow (I), Tetbury Road

The inn originally stood in Earl Bathurst's grounds but was demolished in the early 1850s. In 1856 the site was used for the first Corinium Museum, built to display the Roman mosaics uncovered in Dyer Street in 1849. In 1938 the museum moved to its present location in Park Street. The earliest documentary reference to the Barley Mow is around 1800, and local directories in 1822 list Edward Perring as landlord of the tavern and public house, with a secondary occupation as a currier and leather cutter.

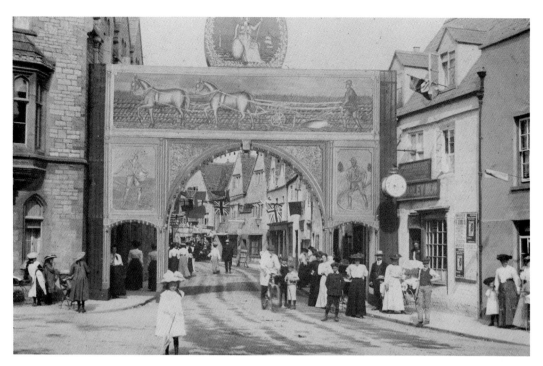

Barley Mow (II), Castle Street

Service and the name moved across the road in the 1850s. Perring retired but the Barley Mow name was adopted by George Hinton, a beer retailer and carpenter, living in a house next to the Three Compasses and two doors down from the Three Cocks. The sixteenth-century building is now a hairdresser's. Bill Butler was the last landlord when it closed in 1954. As a Cripps pub, and following company tradition, the inn sign was reproduced as a Christmas card.

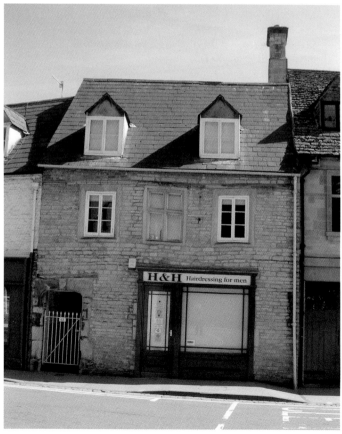

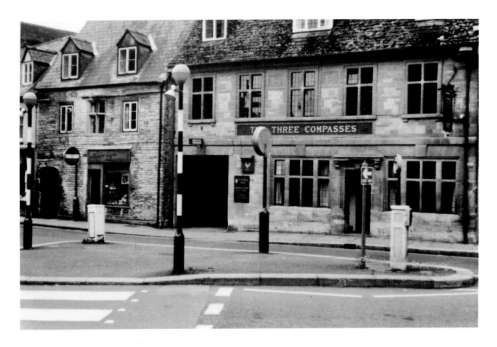

Three Compasses, Castle Street

From Carpenters' Arms to Three Compasses and now Somewhere Else – two name changes in the course of three centuries. In 1805 the pub was leased to Joseph Cripps and continued an association with Cripps, later Cirencester Brewery for many years. Rebuilt in 1919, the initials 'CB' referring to Cirencester Brewery applied equally well to Courage's Brewery when they were the owners. Since 2010, Somewhere Else has served a tapas-style menu in refurbished surroundings.

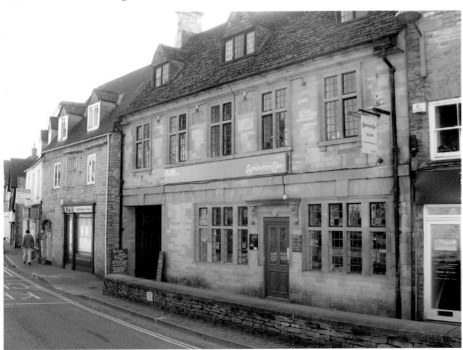

Cricklade Street
 Bell – New and Old
 Cirencester Brewery
 Three Horse Shoes
 Bishop Blaize
 Wheatsheaf
 Maltings
 Brewers Arms
 Rose & Crown

Lewis Lane
 Cotswold Brewery

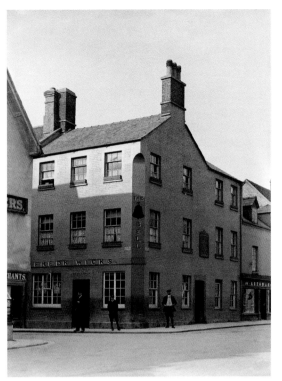

Bell (New), Cricklade Street

'At the sign of the Bell' marks the site of the second Bell, a short remove from its predecessor. The building which today occupies the corner site with Castle Street dates from 1853. The coloured façade with imitation ashlar facing hides a brick structure whose doors and windows shift and change over time. The Sweetings, successors to Frederick Wicks, enjoyed a long tenancy at the beginning of the twentieth century entertaining the Corinium Lodge of Oddfellows and between the wars providing a training room for a boxer. The Bell had closed by 1957.

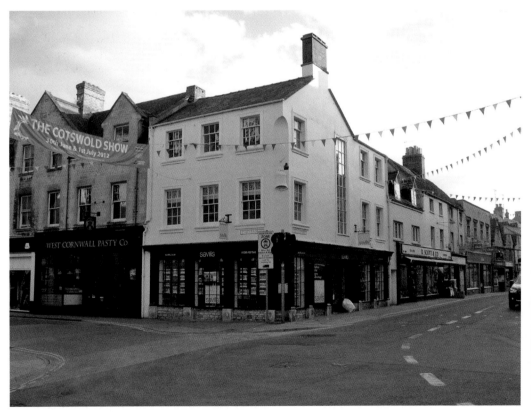

Bell (Old), Cricklade Street

The original Bell, to the right of the cyclist in the middle distance, was a late medieval building with its own brewhouse. 'Le Bell' is first recorded in 1540 but trade appears to have moved to the new site at the 'top of the town' by around 1800. The old Bell was eventually demolished and replaced by a row of shops in 1939 when the entrance to Cripps Brewery was widened, with the loss of its timber-framed inner courtyard. The former assembly room had been demoted to a hop store for the brewery before demolition.

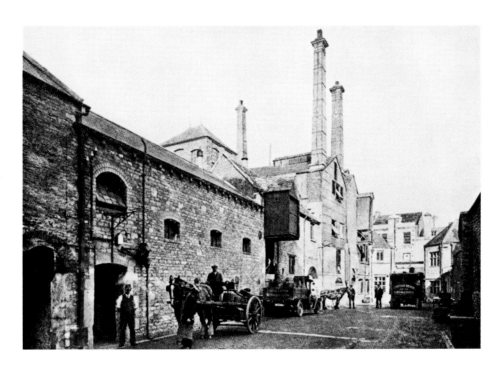

Cirencester Brewery, Cricklade Street

The brewery business was founded in 1798 and by 1820 was trading as Croome, Cripps & Company. The Cripps family maintained a prominent share in the business and developed extensive premises behind the original Bell Inn, with a change of name in 1887 to Cirencester Brewery Ltd. By 1920 the firm owned ninety-two licensed houses in a 25-mile radius of the town. In 1937 the brewery amalgamated with H. & G. Simonds Ltd. of Reading. Operations were scaled down and brewing had ceased by 1949. The surviving buildings are now home to New Brewery Arts and the Niccol Centre.

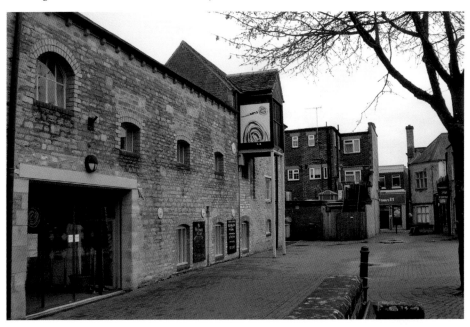

Three Horse Shoes, Cricklade Street

Originally the Shoulder of Mutton, the inn had changed its name by 1801. An inventory of 1821 lists 'in the brew house large copper furnace, grate kerb, cover and hood, pit grate, small brass boiler, mash tub on stove'. Brewing on the premises continued until the 1890s when Smith & Son from Brimscombe Brewery supplied the beer. A succession of licensees extolled the merits of the Commercial Hotel with good stabling for up to forty horses on market days. The licence lapsed in 1917. In the distance, the front of the old Bell can be compared with its modern replacement.

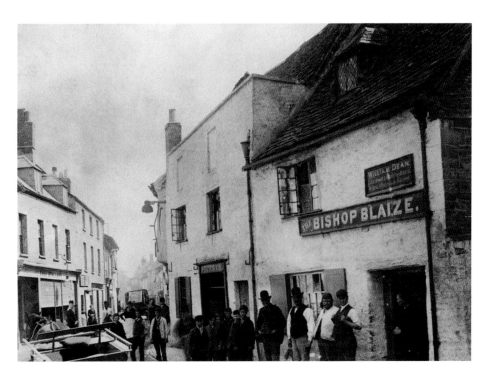

Bishop Blaize, Cricklade Street

What's in a name? Does it come from St Blaise, who was the patron saint of woolcombers – a necessary trade given the importance of wool to the Cotswolds. Or was it named by association with Bishop Hooper, who was burnt at the stake in 1555 and reputedly spent a night in the inn on his way to Gloucester and martyrdom? The dog-leg angle created a traffic bottleneck in Cricklade Street until the inn was rebuilt in 1893 and the road widened. The pub ceased trading in 1962 and was rebuilt as shops.

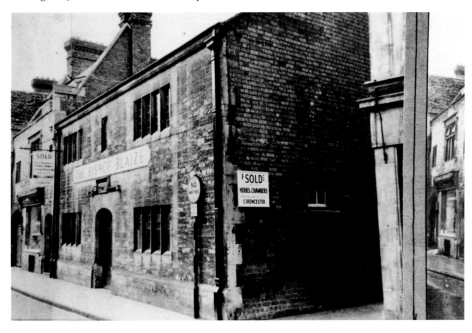

Bishop Blaize, Cricklade Street

The *Cirencester Flying Post* for 27 January 1746 gave 'Notice that on Shrove Tuesday next a good silver watch of five guineas value is to be shot for, at the House of John Bond, at the Sign of Bishop Blaze by a Mark's-Man shooting a single Ball out of a fair Barrell'd Gun, one hundred yards'. There is no record of the outcome. By contrast, the Yaxley family and William Dean appear to have offered good, honest (quiet?) service from the 1840s through to the 1900s, and the pub's popularity attracted American servicemen during the Second World War.

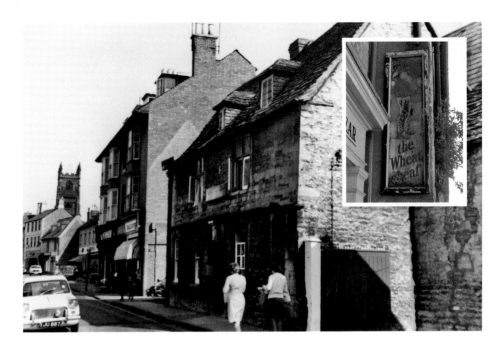

Wheatsheaf, Cricklade Street

Blizzard, Berry, Watts and Orchard (both male and female) succeeded one another from the early nineteenth century as licensees of the Wheatsheaf, serving customers in an inn first recorded in 1782. The building itself is late seventeenth century, and as a tied house has passed from Cirencester Brewery to Simonds of Reading and latterly to Courage. The pub's popularity and financial viability in 1903 is suggested by a rateable value of £24 when shove halfpenny and bar billiards would have been a draw. Today large screens feed the communal enjoyment of high-profile sports events.

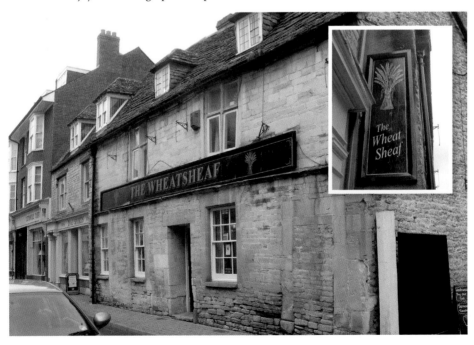

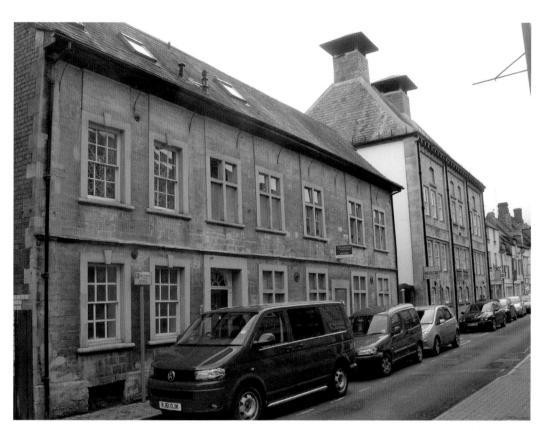

Maltings, Cricklade Street

The skyline is dominated by the capped vents of the former Cirencester Maltings. In 1837 William Howell, licensed maltster, occupied the neighbouring Queen Anne House, his name once adorning the lintel over the blocked door. Cotswold Brewery took over the business in 1867. Cripps Brewery acquired the site in 1877, shortly before their purchase of the Cotswold Brewery in 1882. The Glasgow-based business of Hugh Baird & Sons continued malting from 1945 until 1980, with Maurice Harding completing thirty-five years of service when the kilns were extinguished. The malt floors were demolished and the site converted to sheltered accommodation.

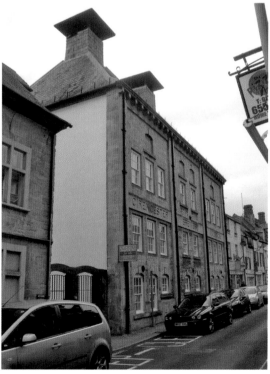

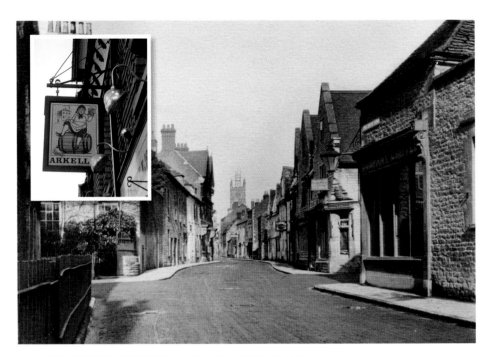

Brewers Arms, Cricklade Street

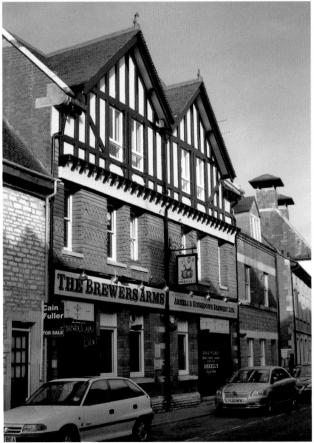

This is a pub with a presence and a façade to stand and admire with its tile-hung first floor beneath half-timbered twin gables. The red Swindon brick of the 1902 rebuild is a pointer to its continuing association with T. & J. Arkell's Kingsdown Brewery. The company archives reveal the purchase in 1869 for £670 of a pub 'known as the sign of the Brewers Arms with bakehouse, brewhouse and other buildings, yard and garden'. Earlier documents suggest the bakehouse may have been converted from a slaughterhouse.

Rose & Crown, Cricklade Street

On a more homely scale, the Rose & Crown would have been typical of the small beer retailers in the town, serving beer as a carry-out in jugs or flagons, and often offering a chance to supplement another job or for the wife to earn a penny. Richard Jones in 1851 was followed by Mrs Sarah Lee by 1872. The premises were leased to Cirencester Brewery by 1891, with a long association with the Cuss family until 1907. Henry Topps was the last landlord in 1922 when renewal of the licence was refused.

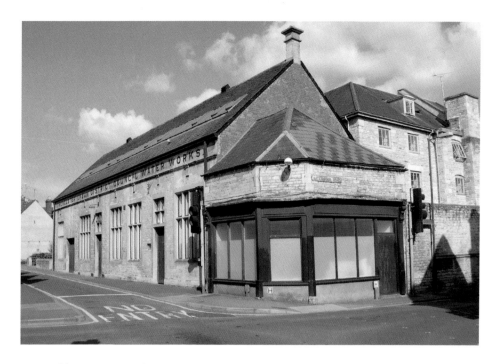

Cotswold Brewery, Lewis Lane

The Cotswold Brewery took advantage of the deep wells later utilised by the Cirencester Urban District Council Waterworks at the junction of Lewis Lane and Watermoor Road. The original malthouse and brewhouse were acquired by the Bowly family in 1824 with expansion in the 1840s to supply local public houses including the Fox and Queen's Head. The brewery was bought out by Cirencester Brewery in 1882 and closed. The site became the base for James Snowsell in partnership with Henry Cole, trading as corn millers and animal feedstuff merchants before conversion in 1998 to residential houses.

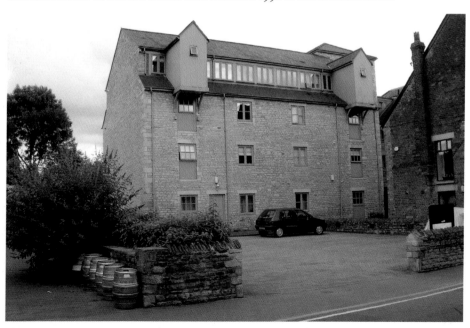

Sheep Street
 Marlborough Arms
 Railway Inn
Querns Lane
 Hope
Lewis Lane
 Twelve Bells
London Road
 Nags Head
 Waggon & Horses
 First & Last
The Beeches
 Golden Farm
Victoria Road
 Talbot

Chester Street
 Oddfellows Arms
Watermoor Road
 Queen's Head
Queen Street
 Foresters' Arms
Watermoor Road
 Plume of Feathers
(Bees Knees)
 Horse and Drill
Chesterton Lane
 Woodbine
Siddington Road
 Goldschmidt Arms

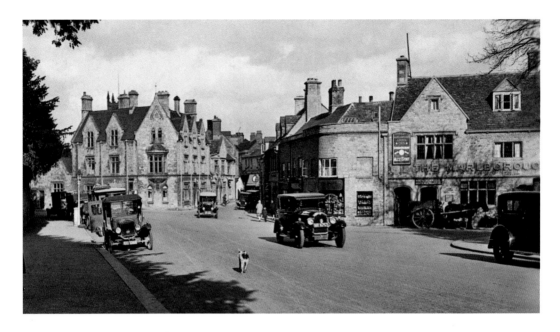

Marlborough Arms, Sheep Street

Tied to the Stroud Brewery, Joel Merchant was the beer retailer at the Marlborough Tavern in 1852. There is a suggestion that the pub may have changed name temporarily to the Mason's Arms in the 1870s but the bold stone carving on the front confirms its name. The pub was rebuilt in 1919 by E. P. Dromgole, and until the closure of the Great Western Railway station on 6 April 1964 it would have enjoyed bustle and passing passenger trade. Large sporting occasions now act as the main attraction.

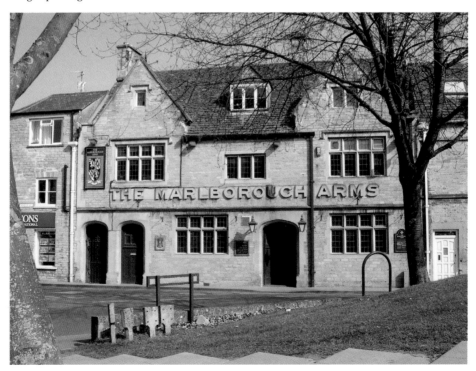

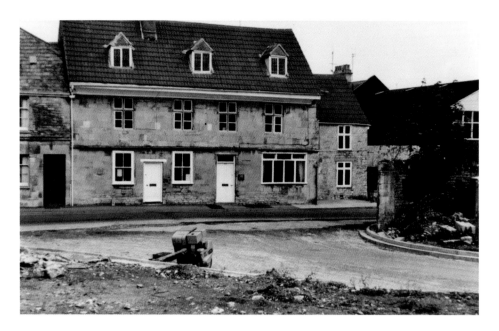

Railway Inn, Sheep Street

The axing of the Great Western Railway link to Kemble was mirrored by the decline in the fortunes of the Railway Inn. In January 1963, Hobbs & Chambers offered for sale by auction, the spacious freehold (de-licensed) premises of the former inn, established in a building of much earlier date after the railway opened in 1841. Owned by the Bathurst family until 1876, the licence passed from Cripps' Cirencester Brewery to Simonds before closure in 1956. In its heyday it would have enjoyed the custom of men working on the nearby sidings and coal yards. The construction of the inner bypass in 1974 created a cul-de-sac and the building has progressed from offices for Bennett's Estate Agents to restaurant.

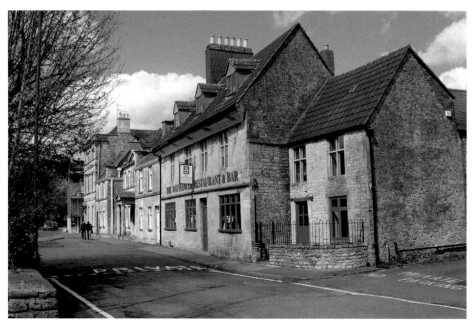

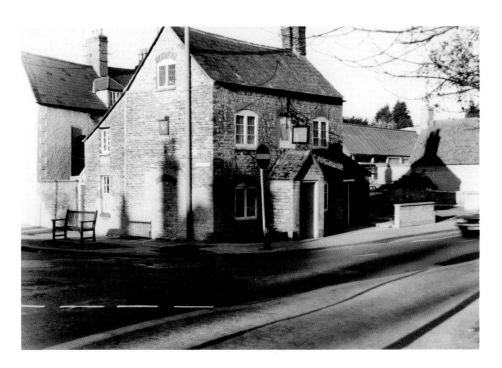

Hope, Querns Lane

All hope of saving the pub failed in 1975. Courage, the then owners, put it up for sale with a scheduled closure on 31 March but such was the thirst of its loyal customers that the beer ran out at lunchtime on 29 March. At the junction with Sheep Street, the Hope was able to enjoy the custom of both railway and canal traffic, and until the 1890s an address 'near the wharf' indicated its proximity to the basin of the Thames & Severn Canal Arm into Cirencester.

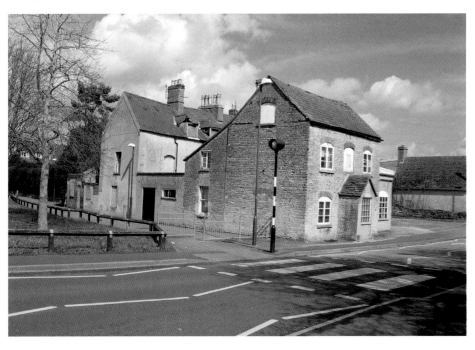

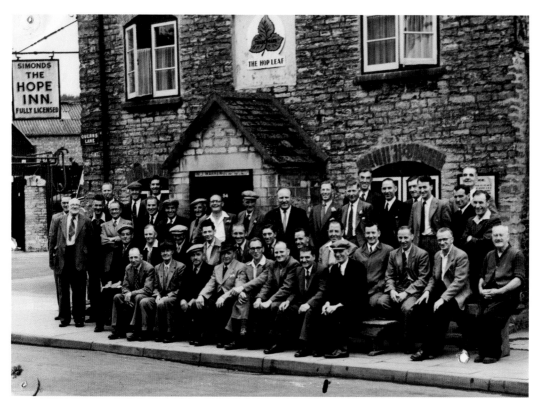

Hope, Querns Lane

The building is now the premises of Sydney Free Saddlers & Country Clothing, but a relic of its life as a pub survives high on the gable wall: a fragment of wall painting advertising Simonds Ales & Stouts, beneath a later sign. The last Saturday in June each year saw the annual gathering for a coach trip and a chance for a group photograph with the driver before setting off. The last pint, no doubt, was back at the Hope.

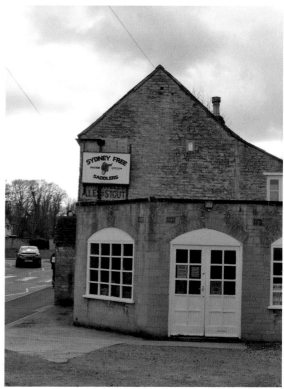

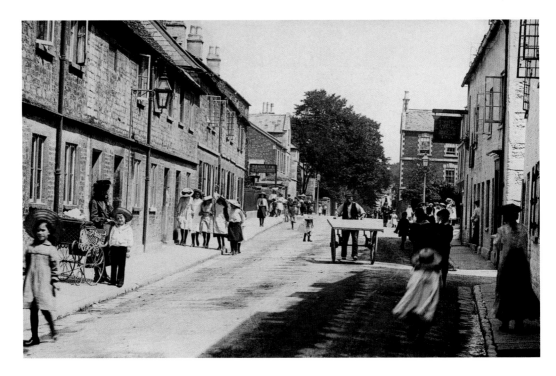

Twelve Bells, Lewis Lane

The Twelve Bells was probably the taphouse for Bowly's Cotswold Brewery, which stood next door. The brewery was bought by Cirencester Brewery in 1882 and was later converted to a flour mill, and more recently to luxury flats. William Hinton is the first known landlord in 1870, at a time when the former nursery grounds south of Lewis Lane were being sold for residential development, a case of satisfying the needs in an area with an expanding population.

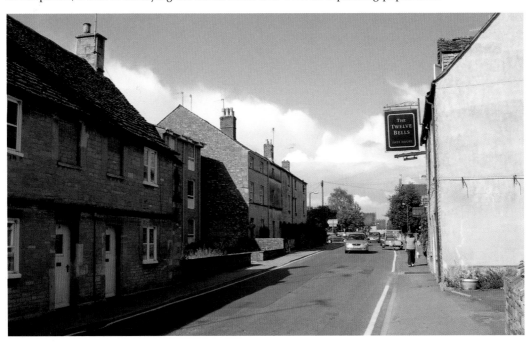

Twelve Bells, Lewis Lane

A brief worrying spell of closure in 2009 has been followed by regeneration and in-house brewing with a microbrewery at the end of the garden. The Twelve Bells was voted County Pub of the Year by the Gloucestershire Branch of CAMRA in March 2001. The pub sign over the years has swung between bluebell flowers and the twelve bells in the tower of the parish church, as seen here, with Canon Lewis unveiling the new sign for pub landlords John and Gladys Meredith.

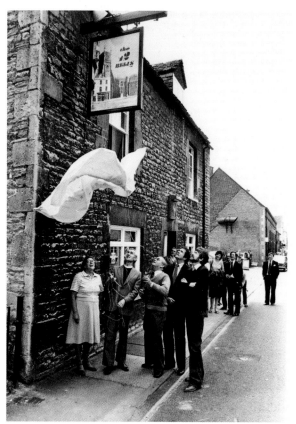

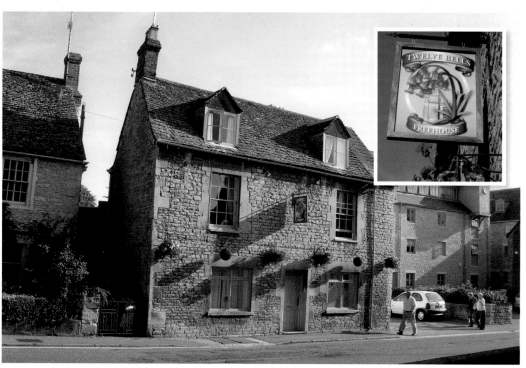

Nags Head, London Road

The name occurs in a title deed as early as 1712. 'Where was the Nags Head?' would be a teasing question in a pub quiz. The answer lies under tarmac and the approach to the Waterloo development of the late 1960s. The tavern had a narrow frontage but a long prospect down Victoria Road. In 1891 the property was part of the Abbey Estate, owned by T. W. C. Chester Master, and was tied to the Cirencester Brewery. By the 1940s it was supplied by Simonds Brewery from Reading.

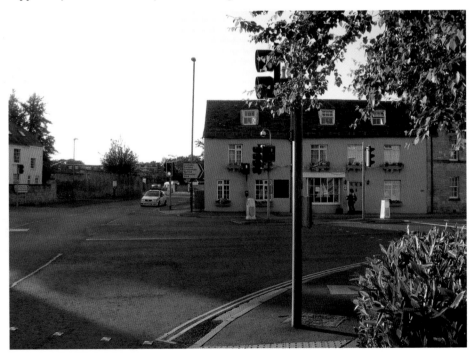

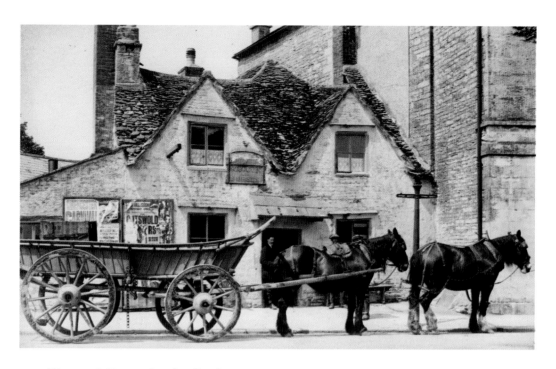

Waggon & Horses, London Road

The importance of the London Road is shown by its link to the capital since Roman times. Beyond the town limits, Roman travellers turned north to follow the Fosse to Lincoln or east on Akeman Street towards St Albans and London. Local traffic since at least 1800, when the Waggon & Horses is first mentioned by name, has relied on its hospitality, and it was a popular stopping point for local carriers on the Fairford and Bibury roads.

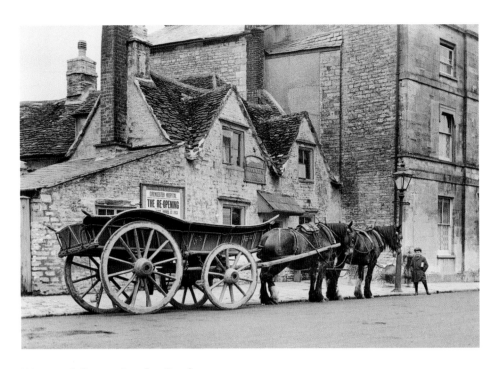

Waggon & Horses, London Road

The original twin-gabled house was enlarged and rebuilt in 1920 by the local firm of R. A. Berkeley in comparable Cotswold style. The chimneys of the original building look rather dangerous and top-heavy in their attempt to draw sufficient draught. Richard Cole appears to have enjoyed a long ownership in the nineteenth century, when the alehouse was tied to Cirencester Brewery. After a spell with Courages, it was acquired in 1998 by Enterprise Inns and today offers a selection of real ales and Thai cuisine.

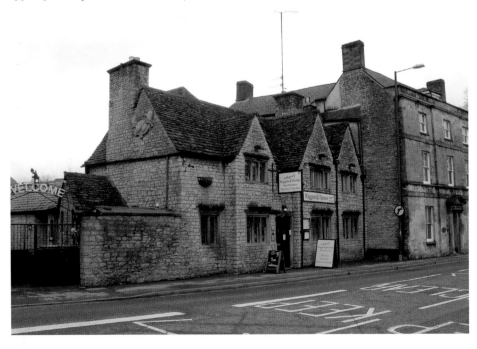

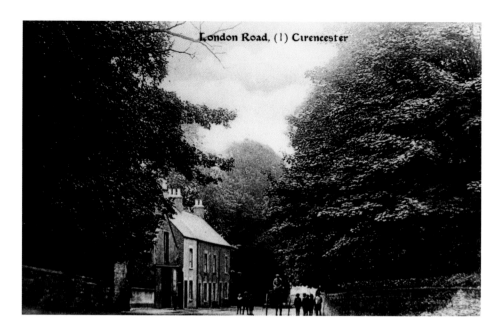

First & Last, London Road

A case of take your pick as to name, known variously as First & Last, Cradle & Coffin or the Beeches Inn. Its position in the middle of a row of cottages at the Beeches explains the first of the three. The property was owned by T. W. C. Chester Master and in its short life Mrs Meriel Lock is listed by the Licensing Authority as beerhouse keeper 1891–1905. A poem published in 1912 in the *Wilts & Glos Standard*, written by a gentleman from Bristol, laments:

> The Star fades away in the brightness of day,
> The Three Cocks are no longer heard,
> Nor more they'll resort in
> The Cradle and Coffin,
> Drinking of Cider and Beer.

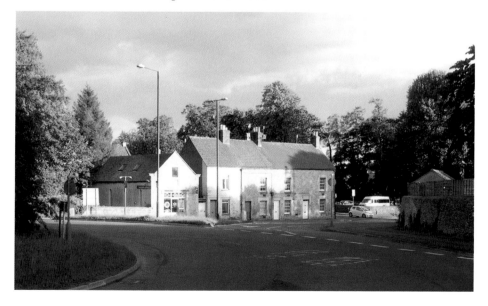

Golden Farm, The Beeches

The Golden Farm functioned as a working farm for over 400 years and was part of the estates acquired by the Master family after the dissolution of the abbey in 1539. Simonds the Brewers had originally intended to build a pub on the corner of Churchill Road and London Road to serve the housing development that became the Beeches Estate from the late 1940s but they bought the Golden Farm instead in 1952 and converted it to its current use.

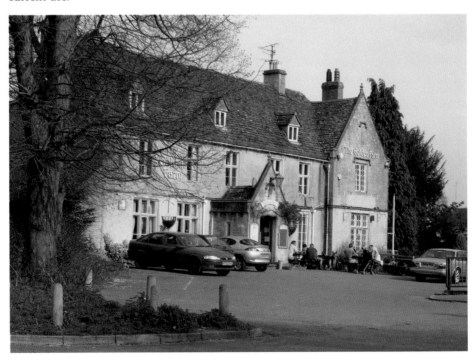

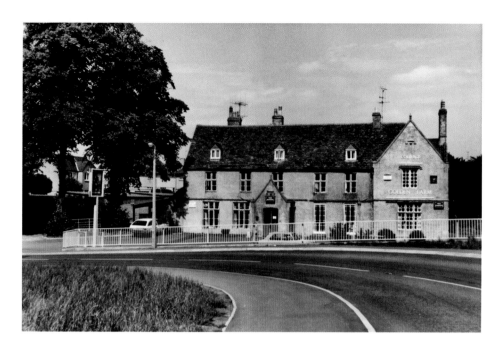

Golden Farm, The Beeches

The line of the 1974 inner ring road and the new approach road into the Beeches Estate have truncated the original much narrower approach to the Golden Farm. Hidden in the undergrowth, the single-span bridge over the River Churn survives, as does the totem signpost. The present building is seventeenth century, with later additions including a skittle alley, but it is probably at least a century earlier in origin. As the farmhouse at the centre of a working farm, it probably dates to the 1550s, when it was described as the New Farm.

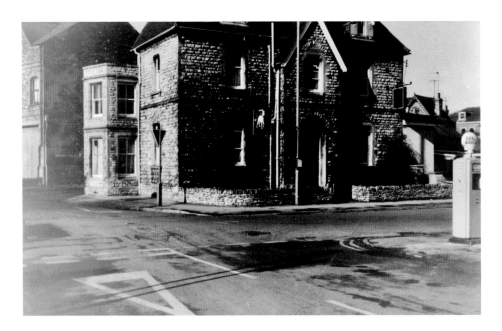

Talbot, Victoria Road

The Talbot sits obediently at the junction of Carpenters Lane with The Avenue and Victoria Road. A new build in 1868 for Daniel Blackford, the alehouse was bought by Arkells Brewery in 1877. In 1900 the landlord, Charles Ferrett, described the Talbot as a hotel, and in recent years outbuildings have been converted to provide bed and breakfast accommodation. It also has to be remembered that until the 1970s Victoria Road was a very busy north–south route used by heavy lorries. A talbot is a breed of hound formerly used for tracking and hunting – another good pub quiz question.

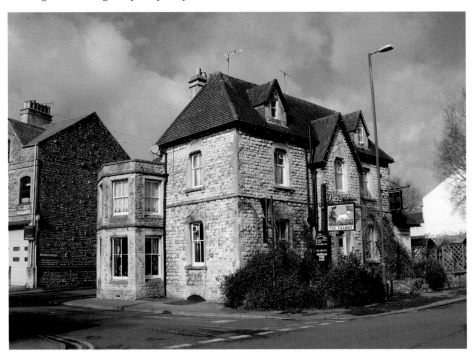

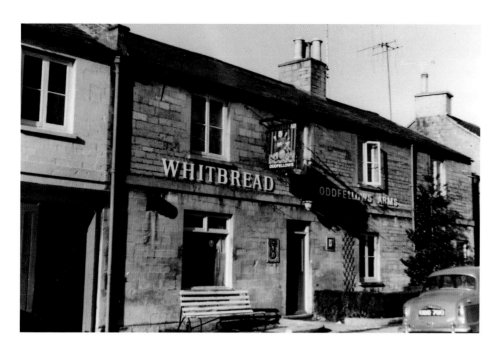

Oddfellows Arms, Chester Street

A close neighbour, the 'Oddies' was described as a simple beerhouse in the 1870s and its homely character blends externally in terms of architecture. Internally, some will remember the small rooms and comfortable sofas in the 1970s, features that have now become the norm for the boutique bars of the twenty-first century. In 1894 the licensee, Joseph Arnold, was agent for the Stroud Brewery, a reminder still etched in the window glass, with an accompanying West Country ceramic wall plate still in situ. The Oddfellows is one of the few pubs in the town to enjoy the bonus of a west-facing garden for a quiet drink on a summer evening.

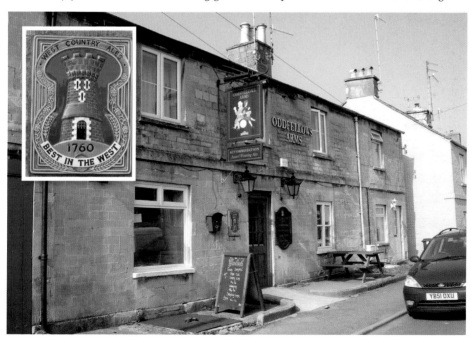

Queen's Head, Watermoor Road

William Bartlett was the first known landlord for the Cotswold Brewery in 1847, with Edwin Cole succeeding him in 1873 shortly before Cripps' Cirencester Brewery bought out the Bowly interest in 1882. Closure in September 2008 and subsequent refurbishment to create three town houses has reinstated the ground plan of the original pub, with its 1901 extension in rusticated stone and adjoining cottage, long used as outbuildings and garaging.

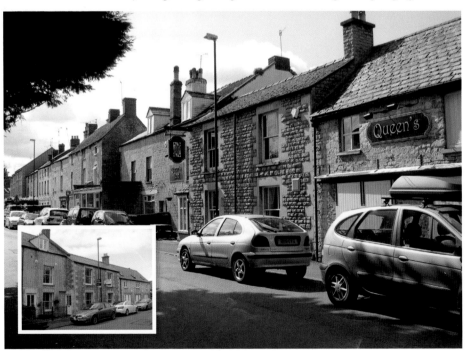

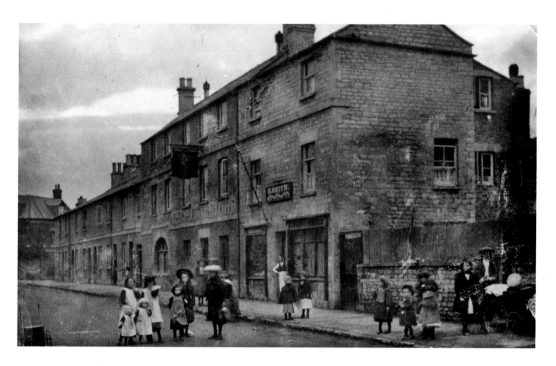

Foresters' Arms, Queen Street

An advertisement for 1912 states: 'Foresters' Arms, Billiard Saloon, H.Q. of the Watermoor Unionist Club, Two Minutes from the Midland & South-Western Junction Railway Station. The best and largest Billiards Room in Cirencester, excellent lights (6 burners over each table).' There must have been stiff competition with neighbouring pubs, but the Foresters' was reputedly allowed to open each morning at six o'clock for workmen to have a drink before starting work at the M&SWJR works. The pub closed in 2003 with the sad loss of its etched glass window, 'Foresters Arms, Bar, beer drawn from the wood'.

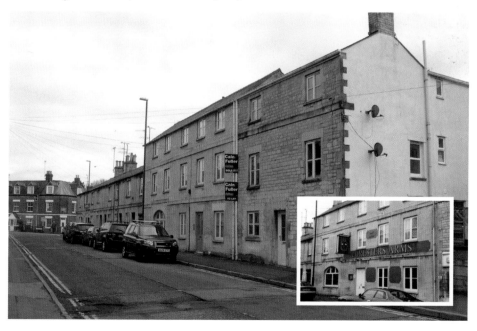

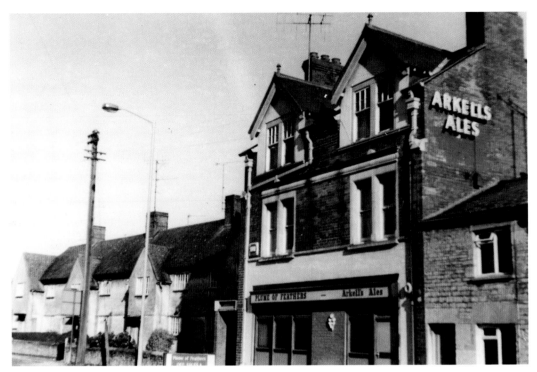

Plume of Feathers, Watermoor Road

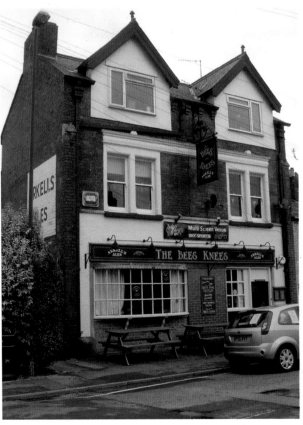

At much the same time as Cirencester Brewery was refurbishing the Queen's Head in 1901, Arkells Brewery was busy re-fettling the Plume of Feathers with its Swindon brick façade to draw in passing trade on the road out of town. Messrs T. & J. Arkell had owned the pub since 1872, and William Keen was listed as the landlord in 1903 with a sideline in bicycle repairs. The pub today trades under the name the Bees Knees.

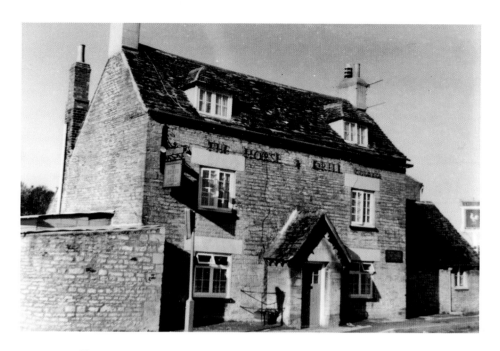

Horse & Drill, Watermoor Road

The cul-de-sac created by the inner ring road opened in 1974 deprived the Horse & Drill of its passing trade, and the premises today serve as a social club for employees of Cotswold District Council. Its outward appearance has changed little since Henry J. Harper was landlord. In 1906 the proprietor advertised: 'Rifle Range 25 yards, food, stabling. Field for Circuses, Shows etc.' By 1930, H. A. Robinson offered charabancs and cars, rather than horses, as a sign of the times. In 1868, Thomas Hensley was selling 'Black Hamburg Grapes, thoroughly ripe and of fine quality. 1/6 per lb' – from his own greenhouse, perhaps?

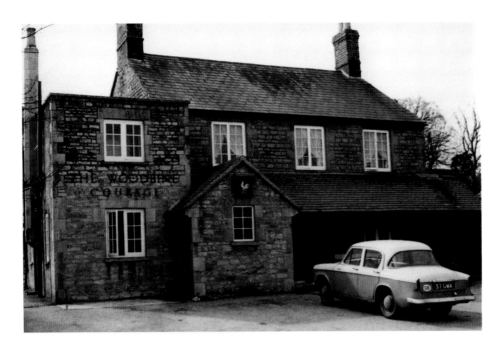

Woodbine, Chesterton Lane

Until the 1930s the Woodbine sat on the edge of the town waiting for the Chesterton housing estates to encircle it. The name may have been originally attached to an inn on the corner of Querns Lane but by 1872 Joseph Pinchin was licensee and owner of the alehouse on Chesterton Lane. Cirencester Brewery had acquired the premises by 1891 with a succession of landlords – George Evans, A. Hesketh, E. Hardy and F. W. Stockham. Tied to the Courage Brewery, Brian Rawson with his wife Barbara took over the tenancy in 1968. The lounge bar to the left was once a shop.

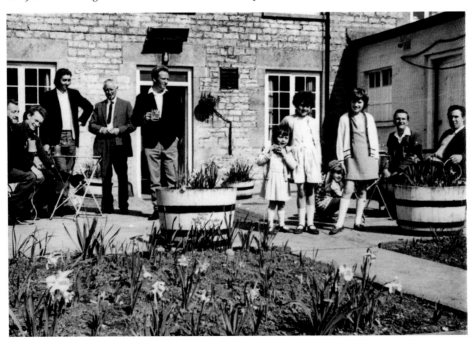

Woodbine, Chesterton Lane

In 1968 members of the Licensed Victuallers Association enjoyed their annual dinner in the King's Head, including, on the left, Brian Rawson, Anne and John Griffiths of the Black Horse, and Barbara Rawson. Members of the Association continue to respond to government and social directives, and strive to support their trade. Sadly in recent years the town has witnessed a number of pub closures. In June 2008 the local newspaper reported the sale of the de-licensed premises and the Woodbine was demolished to be replaced by six houses.

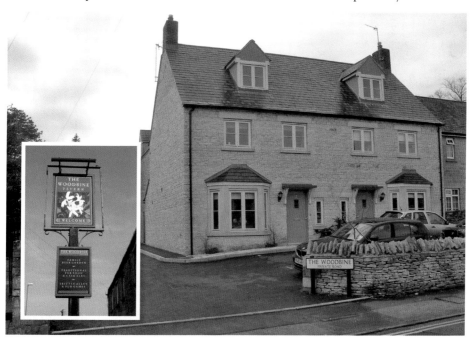

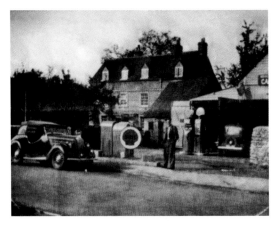

Goldschmidt Arms, Siddington Road
Some changes of name are understandable but why from Bluebell in the 1840s to the Goldschmidt Arms in 1870 when John Grey is listed as landlord? The last known landlord was Charles Durnell in 1896. When did it close? The building stood just beyond the junction of the Siddington and Cricklade Roads and was demolished in the 1970s as it lay in the path of the inner ring road.

Acknowledgements

My main sources of information have been Trade Directories and back copies of the *Wilts & Glos Standard* at the Cirencester Bingham Library and many documents at the Records Office at Gloucester (now Gloucestershire Archives). I am greatly indebted to the staff of both for their help and patience.

Many other people have been most helpful. The late Jean Welsford encouraged me to continue when I felt like abandoning the project. Alan Welsford advised me to set a date to cease research and then write up my notes – good advice that I wish I had taken a lot earlier than I did. My thanks go to Rick Martin, Alan Williams, and Miss Brockman, daughter of a previous owner of the King's Head. To Richard Reece for keeping my feet on the ground, introducing me to the joys and frustrations of a computer – a great help in collating a mine of information – and deciphering the legal jargon of the leases. To the many people of Cirencester who cheerfully answered my many queries. There are too many to mention all by name; in fact some I never even knew their names.

To supplement the postcards and photographs from my own collection, I would like to thank the following for timely additions: Bryan Berkeley, Fay Britton, Brian Court, Edwin Cuss, Rick Martin, Edward Slade, and Linda and David Viner. The early postcards are the work of local photographers such as F. Mortimer Savory, W. Dennis Moss, T. Walker, Henry Cherry and George Roper.

I lay no claim to be a historian. The whole project was undertaken for my own interest and enjoyment, and would have remained so but for the help and encouragement received from Linda Viner.

BLACKWELL SCIENTIFIC PUBLICATIONS
OXFORD LONDON EDINBURGH MELBOURNE

Ph...
Nort...
Great Y...

...Australia

...kwell Scientific Publications
...ord OX2 0EL
...WC1N 2ES
...EH1 2QH

Multiple Choice Questio
Lecture Notes on
Clinical Medicine

CW00820110

© 1978 B...
Osney Mead, O...
8 John Street, London...
9 Forrest Road, Edinburgh...
P.O. Box 9, North Balwyn, Victor...

All rights reserved. No part of this publication
may be reproduced, stored in a retrieval system,
or transmitted, in any form or by any means,
electronic, mechanical, photocopying, recording
or otherwise without the prior permission of the
copyright owner.

ISBN 0 632 00475 4

First published 1978
Reprinted 1979

British Library Cataloguing in Publication Data

Rubenstein, David
 Multiple choice questions on
lecture notes on clinical medicine.
 1. Pathology – Examinations, questions, etc
 I. Title II. Wayne, David
 616'.0076 RB119

ISBN 0-632-00475-4

Distributed in U.S.A. by
Blackwell Mosby Book Distributors
11830 Westline Industrial Drive
St Louis, Missouri 63141,
in Canada by
Blackwell Mosby Book Distributors
86 Northline Road, Toronto
Ontario, M4B 3E5,
and in Australia by
Blackwell Scientific Book Distributors
214 Berkeley Street, Carlton
Victoria 3053

Set by Preface Ltd., Salisbury, and
Printed and bound in Great Britain by
Billing and Sons Ltd., Guildford, London and
Worcester.

CONTENTS

PREFACE

The chief use of Multiple Choice Questions (MCQs) is in revision and discussion. They can sharpen a student's jaded mind – there can be no self-deceiving excuses for a wrong answer after it has been written down. Thus unrecognised lacunae in knowledge can be discovered and corrected. Accordingly, we recommend that the student answer these questions on his own by *writing out* the answers to a whole block of questions. This is preferable to looking up the answer to each question one by one after making a half-hearted mental commitment. This also avoids spoiling the next question by inadvertently spotting the answers to it. It is best to discuss the answers in groups, preferably with a tutor. The merits and de-merits of alternative answers can then be discussed and the appropriate authorities checked in case of disagreement. If you do not like the answers given in this book, you will feel more secure in your disagreement if a whole group of doctors agrees with you. If you think we have made a mistake, please do write and tell us.

The case histories are included to provoke discussion of those topics which we feel benefit most from this approach. The answers given are a brief guide for those who are working on their own. They may help to generate some steam in group discussions – we do not claim that they are the only possible answers.

Reading textbooks is generally very boring and we hope that these questions will add a hint of enjoyment to the grind of study. Good luck – we hope you get all of them right.

January 1978

David Rubenstein
David Wayne

PART ONE

1. **Bitemporal hemiainopia can occur with** :
 A Temporal lobe astrocytoma
 B Craniopharyngioma
 C Pinealoma
 D Internal carotid aneurysm
 E Pituitary tumour

2. **Sudden blindness occurs with:**
 A Vitreous haemorrhage
 B Choroido-retinitis of toxoplasmosis
 C Temporal arteritis
 D Glaucoma
 E Neurosyphilis

3. **A small pupil is seen in:**
 A Argyll Robertson pupil
 B Third nerve palsy
 C Holmes-Adie syndrome
 D Meiotic drugs
 E Mydriatic drugs

4. **The following are typical of Horner's syndrome:**
 A Enophthalmos
 B Anhydrosis
 C Pupillary dilatation
 D Ptosis

1

5. Which of the following muscle innervations are correct:
 A Biceps: C 3–4
 B Triceps: C 7
 C Iliopsoas: L 2,3
 D Sternomastoid: C 1–2
 E Deltoid in shoulder abduction: C 4–5

6. Which of the following reflex innervations are correct:
 A Knee jerk: L 3–4
 B Ankle jerk: L 5
 C Triceps jerk: C 6
 D Biceps jerk: C 5–6
 E Supinator jerk: C 7

7. Which two of the following are the more common causes of paraesthesiae in the fingers:
 A Multiple sclerosis
 B Cervical rib
 C Cervical spondylosis
 D Carpal tunnel syndrome
 E Vitamin B_{12} deficiency

8. Carpal tunnel syndrome occurs in:
 A Syringomyelia
 B Pregnancy
 C Myxoedema
 D Rheumatoid arthritis
 E Gout
 F The contraceptive pill

2

9. Ulnar nerve lesions are characterised by:
 A Weakness of all the thenar muscles
 B Weakness of all the hypothenar muscles
 C Wrist drop
 D Sensory loss over thumb, index and middle fingers
 E Sensory loss over ring and little fingers

10. Ptosis:
 A May follow a partial 7th nerve lesion
 B Occurs in myotonia congenita
 C Occurs in myasthenia gravis
 D Is partial in lesions of the sympathetic nerves
 E May be congenital

11. Facial nerve palsy:
 A Movements of the forehead are retained if the upper motor neurone is involved
 B Is an early feature of acoustic neuroma
 C Occurs in Sarcoid
 D Occurs in Guillain–Barré syndrome
 E Occurs in poliomyelitis
 F Is associated with herpes zoster infection

12. Which of the following are true:
 A Pain and temperature tracts are ipsilateral to the dermatomes
 B Vibration sense is carried in the dorsal columns
 C Patients veer away from the side of cerebellar lesions
 D Dissociated anaesthesia is a feature of motor neurone disease
 E The tremor of Parkinson's disease improves on movement

3

13. **The following are features of hypermetropia:**
 A Concave spectacle lenses
 B Short sightedness
 C Small optic disc on ophthalmoscopy
 D Temporal pallor of the disc
 E Absent ankle and sometimes knee jerks

14. **Subacute combined degeneration of the cord is associated with:**
 A Damage to the dorso-lateral columns
 B MCV of more than $90\mu^3$
 C Absent knee jerks
 D Brisk ankle jerks
 E Stocking anaesthesia to all modalities

15. **Posterior uveitis is associated with:**
 A Inflammation of the choroid
 B Diabetes mellitus
 C Diabetes insipidus
 D Sarcoidosis with normal calcium
 E Sarcoidosis with high calcium
 F Toxoplasmosis

16. **Xanthelasma and xanthelasma-like lesions occur in:**
 A Hyperthyroidism
 B Diabetes mellitus
 C Pseudoxanthoma elasticum
 D Primary biliary cirrhosis
 E Hypercholesterolaemia
 F Dermatomyositis

4

17. Cataracts are associated with:
 A Rubella
 B Hyperparathyroidism
 C Dystrophia myotonica
 D Chloramphenicol
 E Diabetes mellitus
 F Hypothyroidism
 G Chloroquine

18. Very large spleens are typically found with:
 A Infectious hepatitis
 B Pernicious anaemia
 C Myelofibrosis
 D Chronic myeloid leukaemia
 E Long standing cirrhosis

19. In which of the following is ascites usually present on clinical examination:
 A Left ventricular failure
 B Cirrhosis of the liver
 C Intraabdominal Hodgkin's disease
 D Nephrotic syndrome
 E Carcinoma of the uterus

20. Unconjugated hyperbilirubinaemia is characteristic of:
 A Gilberts' syndrome
 B Dubin–Johnson syndrome
 C Rotor syndrome
 D Haemolytic anaemia
 E Chronic active hepatitis

5

21. Jaundice with pale stools and dark urine is characteristic of:
 A Infectious hepatitis
 B Carcinoma of the pancreas
 C Hepatoma
 D Glandular fever hepatitis
 E Primary biliary cirrhosis
 F Chlorpromazine jaundice

22. In obstructive jaundice of the elderly the following may help distinguish between the causes:
 A Bilirubin level
 B Alkaline phosphatase
 C α-feto-protein
 D Serum albumin
 E Prothrombin time
 F Mitochondrial antibody estimation

23. Which of the following may cause dysphagia:
 A Achalasia of the cardia
 B Motor neurone disease
 C Myaesthenia gravis
 D Parkinson's disease
 E Syringomyelia
 F Carcinoma of the stomach

24. The following are typical presenting features of achalasia of the cardia:
 A Mediasternal widening on chest X-ray
 B Retrosternal pain with acid regurgitation
 C Recurrent pneumonia
 D Dysphagia initially with solids more than liquids
 E Weight loss

6

25. **Diarrhoea may occur with:**
 A Pernicious anaemia
 B Diabetes mellitus
 C Sarcoidosis
 D Lincomycin
 E Thyrotoxicosis
 F Carcinoid syndrome

26. **Which of the following are likely to cause acute abdominal pain and rectal bleeding in the elderly:**
 A Haemorrhoids
 B Ischaemic colitis
 C Diverticular disease
 D Ulcerative colitis
 E Carcinoma of the colon
 F Carcinoma of the head of the pancreas

27. **Haemoptysis occurs characteristically in the following:**
 A Tuberculosis
 B Pulmonary sarcoidosis
 C Mitral stenosis
 D Bronchial adenoma
 E Polyarteritis nodosa
 F Bronchiectasis

28. **The following characterise fibrosing alveolitis:**
 A Low FEV/FVC ratio
 B Normal FEV/FVC ratio
 C High $PaCO_2$
 D Low $PaCO_2$
 E Low PaO_2

7

29. **Central cyanosis characteristically occurs with:**
 A Over 5 g/100 ml reduced haemoglobin
 B Pulmonary aspergillosis
 C Status asthmaticus
 D Congenital pulmonary stenosis
 E Polycythaemia rubra vera
 F Multiple pulmonary emboli

30. **In cor pulmonale the following signs are characteristic:**
 A Immediate blowing diastolic pulmonary murmur
 B Quiet pulmonary second sound
 C Left parasternal diffuse heave
 D Hepatomegaly
 E Large 'v' wave in JVP.

31. **Methamoglobinaemia is caused by:**
 A Aspirin
 B Phenacetin
 C Phenylbutazone
 D Shoe polish
 E Primaquine
 F Clindamycin

32. **The following commonly occur in left ventricular failure:**
 A Paroxysmal nocturnal dyspnoea
 B Fine bilateral basal crepitations
 C Right-sided pleural effusion
 D Reversed splitting of the second sound
 E Splenomegaly
 F Pansystolic murmur at the apex

33. **Reduced arterial pulse volume (and pressure) are found in:**
 A Atrial septal defect
 B Pulmonary stenosis
 C Mitral stenosis
 D Patent ductus arteriosus
 E Pericardial tamponade

34. **Increased pulse volume occurs in:**
 A Syphylitic aortic incompetence
 B Rheumatic mitral incompetence
 C Mitral incompetence immediately following myocardial infarction
 D Atrial septal defect
 E Paget's disease

35. **Atrial fibrillation is a typical feature of:**
 A Ischaemic heart disease
 B Friedereich's ataxia
 C Amyloid
 D Thyrotoxicosis
 E Mitral stenosis
 F Constrictive pericarditis

36. **A prominent 'a' wave may suggest:**
 A Atrial flutter with changing block
 B Tricuspid incompetence
 C Ventricular septal defect
 D Pulmonary stenosis
 E Pulmonary hypertension
 F Complete heart block

37. **A prominent 'v' wave may suggest:**
 A Atrial flutter with changing block
 B Tricuspid incompetence
 C Ventricular septal defect
 D Pulmonary stenosis
 E Pulmonary hypertension
 F Complete heart block

38. **The following are typical of mitral stenosis:**
 A Mid-diastolic rumbling murmur
 B Opening snap just following the first sound
 C Loud first sound
 D Recurrent chest infection
 E Relative reduction in blood flow to apices of the lung

9

39. In aortic coarctation:
A Patients are always under 40 at presentation
B Cyanosis may result if untreated
C The murmur may be best heard between the scapulae
D Radio-femoral delay is associated with scapular anastomosis
E Hypertension is invariably reversed by surgery

40. In rheumatic aortic stenosis:
A The pulse volume is reduced
B There is a pansystolic apical murmur
C The aortic second sound is 'clicking' in character
D There is a thrill at the base of the heart

41. In sub-valvar aortic stenosis:
A The arterial pulse character is 'slow rise and fall'
B The murmur radiates to the neck
C The aortic second sound is normal
D β-blocking agents may be helpful

42. In the ECG:
A Left axis deviation may occur in right bundle branch block
B The upper limit of the QRS complex is 0.12 sec
C The 'p' mitrale is best seen in the central chest leads
D The PR interval varies normally with heart rate
E Left bundle branch block is not usually pathological

43. The following are true:
A Delta waves occur in hypothyroidism
B 'U' waves are seen in hypokalaemia
C The 'T' waves are peaked in hyperkalaemia
D 'J' waves suggest hypocalcaemia
E Digitalis toxicity causes ST elevation
F The QT interval is increased in hypercalcaemia

10

44. The following are useful in the treatment of acute pulmonary oedema:
 A Posture
 B Oxygen
 C Frusemide
 D β_2 stimulants
 E β_1 blockers
 F Aminophylline
 G Heroin

45. Which of the following commonly cause iron deficiency anaemia:
 A Thallasaemia major
 B Sickle cell anaemia
 C Menorrhagia
 D Ankylostoma duodenale
 E Ascaris lumbricoides

46. Macrocytic anaemia is associated with:
 A MCV of 80–86 c
 B MCV of 86–96 c
 C MCV of 96–106 c
 D Folic acid deficiency
 E Chronic liver disease
 F Chronic renal disease
 G Primidone therapy

47. Megaloblasts:
 A Are present in large numbers in the marrow in B_{12} deficiency
 B Are normally present in insignificant numbers in the marrow
 C Have polychromatic multilobed nuclei
 D Are associated with leucopenia and thrombocytopenia

11

48. Pernicious anaemia is associated with:
A Antibodies to parietal cells
B Antibodies to intrinsic factor
C Antibodies to thyroid cytoplasm
D Antibodies to mitochondria
E Antibodies to smooth muscle

49. The following features occur in thrombotic thrombocytopenic purpura:
A Haemolytic anaemia and hyperbilirubinaemia
B Capilliary and arteriolar emboli in the kidneys
C Abnormal neurological signs
D LE cells in the peripheral blood
E Response to heparin

50. Paroxysmal nocturnal haemoglobinuria is associated with:
A Macrocytosis in the peripheral blood
B Chronic bronchitis and high PaO_2
C Positive Ham's test
D Reduced red cell acetyl cholinesterase
E Red cells in the urine

51. In iron deficiency anaemia:
A The MCV is usually normal
B The MCH is usually reduced
C Plasma iron is less than 40 μmol/litre
D Iron binding capacity is above 65 μmol/litre

52. Eosinophilia in the peripheral blood is seen in:
A Polyarteritis nodosa
B Pulmonary aspergillosis
C Asthma
D Pulmonary sarcoidosis
E Interstitial pulmonary fibrosis

12

53. In polycythaemia rubra vera:
A Splenomegaly and lymphadenopathy are common
B The PaO_2 is usually reduced
C Central cyanosis may occur
D Red cell mass is increased
E WBC and platelet counts are raised

54. The bleeding time is prolonged in:
A Scurvy
B Secondary thrombocytopenia
C Haemophilia
D Christmas disease
E Osler Rendu Weber disease
F Osgood—Schlatter's disease
G von Willebrand's disease

55. Multiple myeloma is characterised by:
A Aplastic anaemia
B Hypercalcaemia
C Excess immunoglobulin, usually IgA
D Bence—Jones heavy chain immunoglobulins
E Nephrotic syndrome

56. Generalised lymphadenopathy is characteristic of the following infections:
A Bacillary dysentery
B Schistosomiasis
C Toxoplasmosis
D Echinococcus
E Tuberculosis
F Recurrent malaria

13

57. **In Hodgkin's disease:**
 A Herpes zoster is common in untreated patients
 B Stage III indicates involvement above and below the diaphragm
 C The central nervous system is occasionally involved
 D Prognosis is better if the glands are lymphocyte free
 E Prognosis is better in men
 F 5-year survival with modern therapy is about 80%

PART TWO

NEUROLOGY

58. **Cluster headaches:**
 A Suggest the presence of an underlying tumour
 B Are rarely unilateral
 C Typically cause unilateral congestion of the eye and nostril
 D Are sometimes precipitated by phenylbutazone
 E Usually respond to ergotamine

59. **The following features are characteristic of trigeminal neuralgia:**
 A Onset usually between 30 and 40 years
 B Rarely unilateral
 C Sulthiame is a drug of first choice
 D Relieved sometimes by carbamazepine
 E Triggered by chewing
 F An auditory aura may precede attack

60. **Subdural haematoma:**
 A Is more common in the elderly alcoholic
 B May be present with progressive dementia
 C A history of previous trauma is invariable
 D Ipsilateral headache often indicates the side of the lesion
 E May be bilateral

15

61. Extradural haematoma:
 A A history of previous trauma is invariable
 B The patient is usually over 40
 C Presenile dementia may be the presenting feature
 D Loss of consciousness is uncommon
 E Loss of consciousness is a late event

62. Which of the following occur in the lateral medullary syndrome (posterior inferior cerebellar artery thrombosis):
 A Dysphagia
 B Ipsilateral Horner's syndrome
 C Nystagmus to the side of the lesion
 D Ipsilateral cerebellar signs
 E Ipsilateral 5th nerve dissociated sensory deficit
 F Contralateral dissociated anaesthesia to the limbs

63. Which of the following features will help distinguish between grand mal epilepsy and other causes of transient unconsciousness in the elderly:
 A The presence of an aura
 B Aortic stenosis
 C A history of chronic bronchitis
 D Right bundle branch block on the ECG
 E Perspiration with attacks

64. Petit mal:
 A Usually begins in early adolescence
 B Is characterised by tongue biting during attacks
 C Is commonly associated with migraine
 D Has characteristic EEG with spike and wave formation at 30 cycles per second
 E Attacks may be followed by automatism

65. Meningitis:
 A Is usually caused by enteroviruses
 B The meningococcus and *Haemophilus influenzae* are the common bacteria in adult meningitis
 C Penicillin is the treatment of choice for pneumococcus and haemophilus meningitis
 D Meningococci appear as Gram-positive diplococci
 E Leprospira icterohaemorrhagica may cause meningitis and is sensitive to penicillin

66. Multiple sclerosis is suggested by:
 A Transient diplopia in a 24-year old woman
 B Pain in the eye and blurring of vision in a 74-year old man
 C Slow progressive paraplegia in a 60-year old woman
 D Trigeminal neuralgia in a 30-year old woman
 E Bilateral blurring of near vision in a 40-year old woman

67. Extrapyramidal symptoms may be caused by:
 A Levodopa
 B Chlorpromazine in the absence of jaundice
 C Copper deposition in the CNS
 D Haloperidol
 E Chloramphenicol
 F Primaquine
 G Reserpine

68. Patients with Parkinson's disease may improve with:
 A Atropine
 B Levodopa
 C Ethosuximide
 D Methysergide
 E Benzhexol
 F Amantidine
 G Amitryptiline if the patient is depressed
 H Bromocryptine

69. **The following are features of Wilson's disease:**
 A Kayser-Fleischer rings which are diagnostic and due to copper deposition
 B Inheritance is recessive
 C High copper levels in serum
 D Increased serum caeruloplasmin levels
 E Slurred speech
 F Normal urinary copper

70. **Huntington's chorea:**
 A Is transmitted as a Mendelian recessive
 B Characteristically first presents in late teens and early 20's
 C Affects mainly the limbs and face
 D Is improved by trimethoprim
 E Is improved by tetrabenazine
 F Progressive dementia is common

71. **Raised intracranial pressure is suggested by:**
 A Photophobia
 B Blurring of vision
 C Neck stiffness and positive Kernig's sign
 D Headache characteristically present on waking
 E Nausea

72. **Acoustic neuromas:**
 A Are fibromas of the 7th cranial nerve and thereby cause facial palsy
 B Are bilateral in 30% of cases
 C May cause tinnitus and deafness
 D May cause vertigo
 E Do not usually alter the CSF

73. **Edrophonium:**
 A Rapidly reverses muscle fatigue in myasthenia gravis
 B Rapidly reverses muscle fatigue in Eaton-Lambert syndrome
 C Inhibits cholinesterase
 D Is reversed rapidly by pyridostigmine
 E Is effective orally only if given not less than 6-hourly

74. **The following features of motor neurone disease are characteristic:**
 A Onset normally between 15 and 25
 B Upper motor neurone destruction is uncommon
 C Diminution of sensation to light touch and pain with loss of reflexes
 D Neostigmine rarely gives improvement
 E Life expectancy is 10–15 years after presentation

75. **In Friedereich's ataxia:**
 A Death may occur from heart failure
 B Absent reflexes in the legs may be associated with up-going plantar responses
 C Dementia is a common early finding
 D Cerebellar ataxia is a common early finding
 E Bulbar palsy is a late feature

76. **The following are typical features of tabes dorsalis as compared with meningo-vascular syphilis:**
 A Lightning pains
 B Onset within 5–10 years of original infection
 C Ptosis
 D Sensory deficit over the nose and sternum
 E Transverse myelitis and paraplegia

19

77. **Syringomyelia causes:**
 A Sensory deficit to pain and vibration in the hands
 B Wasting of the small hand muscles
 C Horner's syndrome
 and may be improved by:
 D Vitamin B_{12} injections
 E Neurosurgery

78. **In a patient with a sudden onset of weakness in both legs:**
 A Hysteria is the most common cause
 B Subacute combined degeneration is a likely cause
 C If a young man he may have prolapsed a disc
 D Lumbar puncture should be performed urgently
 E A neurological opinion must be sought as an emergency

PSYCHIATRY

79. **In depression:**
 A Paranoid delusions are common
 B Early morning waking is characteristic
 C There is loss of libido
 D Memory for recent events is poor
 E Tricyclic antidepressants have adrenergic side effects

80. **The following are well recognised causes of acute confusion:**
 A Acute porphyria
 B Thyrotoxicosis
 C Myxoedema
 D Hypoglycaemia
 E Cushing's syndrome

20

81. **Elderly patients with dementia:**
 A Lose memory for recent more than past events
 B Suffer from marked emotional lability
 C Have paranoid delusions
 D Typically lose interest in friends and relatives
 E Are frequently depressed
 F May occasionally respond to vitamin B_{12} or thyroxine

82. **Schizophrenia:**
 A Occurs in about 0·5% of the population
 B Eventually always requires hospitalisation despite pheno-thiazine therapy
 C May be familial
 D Is frequently associated with shyness and hallucinations

CONNECTIVE TISSUE AND RHEUMATIC DISEASES $8\,o$

83. **Polyarteritis nodosa:**
 A May present with myocardial infarction
 B Is associated with LE cells in 80% of cases
 C Hypertension occurs in 60% of cases
 D Presents as late onset asthma in 20% of cases
 E Abdominal pain occurs in 25% of cases
 F Renal failure is uncommon

84. **Dermatomyositis is characterised by:**
 A Onset at 25–35, mainly in women
 B Underlying malignancy
 C Cardiac failure
 D Telangiectasia affecting mainly the face and upper chest
 E Occasionally improves with prednisolone despite chronicity

21

85. **Systemic sclerosis may result in:**
 A Malabsorption
 B Renal failure
 C Presentile dementia
 D Pulmonary fibrosis
 E Mononeuritis multiplex

86. **The following features typify polymyalgia rheumatica:**
 A Weakness of proximal upper limb muscles
 B Onset usually between 50 and 60
 C Underlying carcinoma
 D ESR raised between 50 and 70
 E Slow but progressive response to steroids

87. **Which of the following are features of systemic lupus erythematosus:**
 A Thrombocytopenia
 B Fits
 C Pericardial friction rub
 D Plate-like atelectasis on chest X-ray
 E Isolated pleural effusion

88. **Temporal arteritis is associated with:**
 A Headache usually severe and unilateral
 B ESR of about 100
 C Pyrexia which may be the presenting symptom
 D Sudden blindness
 and is
 E usually excluded by a normal temporal artery biopsy

89. The following complicate or occur with rheumatoid arthritis:

A Acanthosis nigricans
B Episcleritis
C Malabsorption
D Carpal tunnel syndrome
E Amyloid
F Retinitis pigmentosa

90. Which of the following are true of rheumatoid arthritis:

A Severe disability occurs in 25–30%
B Amyloid is rare but usually a serious complication
C Chloroquine is sometimes useful but may cause cataract
D Splenomegaly occurs in about 15% of patients
E Joint involvement is usually asymetrical
F Lung involvement is rarely important

91. Rheumatoid factor is:

A A circulating IgM immunoglobulin
B Usually present if subcutaneous nodules are present
C Positive in over 85% of patients with rheumatoid arthritis
D Usually present in psoriatic arthritis
E Usually present in ankylosing spondylitis
F Present in a significant number of healthy people

92. Felty's syndrome is characterised by:

A Involvement of large joints
B Lymphadenopathy
C Hypersplenism
D Improvement of joint symptoms following splenectomy
E Positive rheumatoid factor

93. In Sjögren's syndrome the following are usually true:
 A Negative rheumatoid factor
 B Vaginal atrophy
 C Positive Schirmer's test
 D Positive antinuclear factor
 E Xerostomia

94. The following are features of psoriatic arthritis:
 A Subcutaneous nodules
 B Negative rheumatoid factor
 C Severe mutilating arthritis
 D Involvement of the distal interphalangeal joints
 E Associated sacroileitis

95. Joint involvement is characteristically symmetrical in:
 A Osteoarthritis
 B Gonococcal arthritis
 C Rheumatoid arthritis
 D Gout
 E Psoriatic arthritis

96. In ankylosing spondylitis:
 A Ulcerative colitis may coexist
 B Iritis occurs in 30%
 C Rheumatoid factor is usually present
 D Respiratory failure may occur
 E There is high correlation with HLA 13

97. Reiter's disease is associated with:
 A Sacroileitis
 B Muscular spasm (Reiter's cramp)
 C Pustular hyperkeratosis of the palms
 D Circinate balanitis
 E Bacillary dysentry
 F Positive Reiter's complement fixation test (about 60%)

24

98. Acromegaly is associated with:
 A Bitemporal upper quadrantic hemianopia
 B Thickening of the heel pad and tufting of the terminal phalanges
 C Raised levels of growth hormone which can be suppressed with glucose
 D Hypertension in 40%
 E Excessive perspiration

99. Polyuria and polydipsia occur in:
 A Acute glomerulonephritis
 B Hysterical polydipsia
 C Hyperkalaemia
 D Hypocalcaemia
 E Intracranial sarcoid

100. Which of the following occur in hyperthyroidism:
 A Raised TSH levels
 B Vitiligo
 C Atrial fibrillation which is reversed by digitalis
 D Tachycardia which is sensitive to β-blockade
 E Carpal tunnel syndrome

101. Which of the following may be related to hypothyroidism:
 A Congenital blindness
 B Low serum B_{12}
 C Low serum folate
 D Congenital deafness
 E 'J' waves on the ECG
 F Psoriasis

102. **Thyroid enlargement may occur with:**
 A Hashimoto's disease
 B Aspirin therapy
 C Phenacetin therapy
 D Carbimazole therapy
 E Phenylbutazone therapy

103. **Which of the following are true:**
 A The TRH test is helpful in hypothyroidism
 B Anaemia in myxoedema may be macrocytic
 C TSH is reduced in primary hypothyroidism
 D β-blockade is adequate therapy in mild hyperthyroidism
 E Iodine uptake is reduced by PAS, INAH and phenothiazines

104. **Thyroid carcinoma:**
 A Usually takes up excessive radioactive iodine
 B Is usually 'Follicular' and may present as an enlarged gland in the neck
 C Sometimes regresses if thyroxine is given
 D Follows radiation to the neck
 E May secrete parathormone

105. **The following complicate steroid therapy:**
 A Vitiligo
 B Diabetes mellitus
 C Anhydrosis
 D Diabetes insipidus
 E Osteoporosis
 F Hypercalcaemia
 G Skin atrophy

106. **In Cushing's syndrome:**

TRUE →
 A Adrenal adenomas are present in 20%
 B Adrenal carcinomas are present in 10%
 C Hyperpigmentation is found in the buccal mucosa
 D Confusion may occur
 E Proximal myopathy may occur
 F The diurnal cortisol variation is exaggerated

107. **The Waterhouse Friderichsen syndrome is characterised by:**
 A Paroxysmal hypertension
 B Generalised purpura
 C Pneumococcal septicaemia
 D Acute adrenal haemorrhage

108. **Phaeochromocytoma:**
 A Usually presents with paroxysmal hypertension
 B Is invariably benign
 C May not always be found in the adrenal gland
 D Is easily detected on IVP
 E May be detected by ultrasound

109. **In carcinoid syndrome:**
 A The primary tumour is usually in the ileum
 B Liver metastases are invariably present
 C Asthma and/or diarrhoea may occur
 D Pulmonary stenosis occurs rarely
 E Urinary VMA is raised in 70–80%

110. **Which of the following are true:**
 A Phaeochromocytomas cause α and β adrenergic effects
 B Bronchial adenomas are usually carcinoid tumours
 C Conn's syndrome results from adenomas of the Zona fasciculata
 D Growth hormone deficiency is never an isolated phenomenon
 E The Synacthen (tetracosactrin test) may help distinguish adrenal hyperplasia from carcinoma

111. **Diabetes mellitus is present if:**
 A The fasting sugar is 120 mg% (6·7 nmol/litre)
 B A random sugar is 160 mg% (8·9 nmol/litre)
 C 2-hour post-prandial sugar is 160 mg% (8·9 nmol/litre)
 D Microaneurysms are present
 E Nodular glomerular sclerosis is present

112. **The following complications definitely improve with good diabetic control:**
 A Peripheral neuropathy
 B Mononeuritis multiplex
 C Vulvo-vaginitis
 D Proximal amyotrophy (Garland's syndrome)
 E Angina
 F Lipodystrophy

113. **Glycosuria may occur with:**
 A Phaeochromocytoma
 B Carcinoid tumour
 C Cushing's syndrome
 D Haemochromatosis
 E Subarachnoid haemorrhage
 F Hepato-lenticular degeneration

114. **Which of the following kidney disorders occur in diabetes mellitus:**
 A Diffuse glomerular sclerosis
 B Nodular glomerular sclerosis
 C Pyelonephritis
 D Acute papillary necrosis
 E Nephrotic syndrome

28

115. In diabetes mellitus which of the following may occur:
 A Retinitis proliferans
 B Retinitis pigmentosa
 C Necrobiosis lipoidica
 D Nocturnal diarrhoea

116. In diabetic ketoacidosis:
 A Underlying infection is invariably present
 B Previous diabetes is unsuspected in 60%
 C Gastric dilatation is common and may lead to aspiration pneumonia
 D Fluid replacement may cause considerable improvement before insulin is started
 E Long-term insulin will always be needed

117. Which of the following are true:
 A Lactic acidosis tends to occur in insulin dependent diabetes
 B Hyperosmolar coma is more common in the elderly and obese
 C Large doses of insulin are required in lactic acidosis
 D Large doses of insulin are required in hyperosmolar coma
 E Ketonuria is minimal in lactic acidosis and hyperosmolar coma

118. In acute intermittent porphyria:
 A Abdominal pain may be the presenting symptom
 B Hypotension and brachycardia are characteristic
 C Photosensitivity is common
 D Urinary porphobilinogen is raised and makes the urine darken on standing in the light

29

119. **In Fredrickson's Type IV hyperlipidaemia:**
 A The triglycerides are predominantly raised
 B The chylomicrons are predominantly raised
 C Diabetes and gout may be associated
 D Achilles tendinitis may be associated
 E Nephrotic syndrome may be the presenting feature

120. **In osteoporosis:**
 A Bone fractures are uncommon
 B Proximal myopathy occurs
 C The bone matrix is calcified normally
 D Underlying thyrotoxicosis may be present
 E Oestrogen therapy is effective

121. **Tetanus may occur with or following:**
 A Radio-iodine therapy
 B *Chlostridium welchii* infection
 C Osteomalacia
 D Hyperventilation syndrome
 E Partial thyroidectomy

122. **Which of the following are true:**
 A 1-25-Hydroxycholecalciferol is made in the liver
 B Sclerotic deposits occur rarely in myeloma
 C The alkaline phosphatase is elevated in osteoporosis
 D The alkaline phosphatase is greatly elevated in Paget's disease
 E Salmon calcitonin may relieve bone pain in Paget's disease

123. **Hyperparathyroidism may be complicated by:**
 A Psychosis
 B Peptic ulceration
 C Renal colic
 D Thirst, vomiting and constipation
 E Proximal myopathy

124. **Hypercalcaemia is caused by:**
 A Hypervitaminosis D
 B Oat cell carcinoma of the lung
 C Sarcoid
 D Multiple myelomatosis
 E Pseudo-pseudo hypoparathyroidism
 F Secondary hyperparathyroidism
 G Tertiary hyperparathyroidism

125. **Hypercalcaemic patients may respond to:**
 A Aluminium hydroxide
 B Intravenous saline
 C Intravenous phosphate
 D Bendrofluazide
 E Corticosteroids
 F Oral methyl-testosterone
 G Intramuscular calcitonin
 H Bed rest and immobilisation

126. **Serum uric acid may be raised by:**
 A Aspirin
 B Indomethacin
 C Allopurinol
 D Bendrofluazide
 E Phenylbutazone
 F Treatment of Hodgkin's disease

127. **Gout is associated with:**
 A Hyperthyroidism
 B Hypertension
 C Negative refractile crystals in joint fluid
 D Pseudocyst formation on X-ray in the periarticular regions
 E Renal colic

31

128. Which of the following may be useful in acute gout:
 A Allopurinol
 B Phenylbutazone
 C Aspirin
 D Indomethacin
 E Pyrazinamide

129. Calcification of cartilage occurs in:
 A Osteopetrosis
 B Hyperparathyroidism
 C Pseudo-gout
 D Chronic osteoarthritis
 E Reiter's disease

RENAL DISEASE $5 5$

130. On the IVP:
 A Normal adult kidneys are about 10 cm in length
 B 'Foetal lobulation' is associated with intrinsic disease
 C Excretion of dye is normally complete in 20–30 minutes
 D Polycystic disease produces a characteristic appearance
 E Acute tubular necrosis produces a diagnostic appearance

131. Polyuria and polydipsia may be presenting features of:
 A Hyperkalaemia
 B Chronic glomerular nephritis
 C Nephrogenic diabetes insipidus
 D Hypocalcaemia
 E Diabetes mellitus

32

132. **In the nephrotic syndrome:**
 A Underlying diabetes mellitus is present in about 50%
 B The blood urea may be low, normal or high
 C Peripheral oedema is not always present
 D Proteinuria is rarely less than 8–10 g/24 hours
 E Microscopic haematura is invariably present

133. **In acute tubular necrosis**
 A The patient is invariably symptomatically very ill
 B Hypotension is present
 C Hypotension may be the cause
 D Urine output is less than 400 ml/24 hours

134. **The following are typical features of chronic renal failure:**
 A Anaemia
 B Raised serum calcium
 C Raised serum phosphate
 D Raised serum bicarbonate
 E Urine specific gravity is high

135. **Which of the following are true:**
 A Urine specific gravity in hypovolaemia is high
 B Urine specific gravity in tubular necrosis is high
 C Phenacetin and primaquine cause analgaesic nephropathy
 D Gentamicin (given alone) is nephrotoxic
 E Uraemic bone disease may be helped by 1-α-hydroxy-cholecalciferol

136. **Which of the following are true:**
 A Serum complement is reduced in chronic glomerular nephritis
 B In acute glomerular nephritis complete recovery occurs in 90% of adults and children
 C Minimal change nephritis correlates with selective protein-uria and good prognosis
 D Membraneous change nephritis indicates good prognosis
 E *E. coli* (40%) and *Proteus vulgaris* (30%) account for most urinary tract infection in general practice

137. Which of the following occur with inappropriate ADH secretion:
 A Confusion and coma
 B Carcinoma of the bronchus
 C Progressive uraemia
 D Low serum sodium with reduced osmolality
 E Low urinary sodium and osmolality

138. Which of the following usually require potassium supplements:
 A Bendrofluazide
 B Frusemide
 C Prednisolone in treatment of Addison's disease
 D Cotrimoxazole
 E Amiloride

139. Hypokalaemia may follow treatment with:
 A Colchicine
 B Triamterene
 C Oxyphenbutazone
 D Carbenoxolone
 E Cimetidine
 F Hydroxocobalamine for pernicious anaemia

140. Which of the following are true:
 A Heparin is given for haemolytic uraemic syndrome
 B Warfarin is given for haemolytic uraemic syndrome
 C Mannitol may prevent the hepato-renal syndrome
 D Prostatectomy may induce sodium retention
 E 60% of body weight is water

LIVER DISEASE *10*

141. Which of the following will distinguish between short and
long incubation hepatitis:
A Splenomegaly
B Australia antigen (hepatitis associated antigen)
C History of alcohol
D Recent dental extraction
E Speed of recovery

142. Which of the following are true:
A Bed rest improves prognosis in serum hepatitis
B Australia antigen can be spread venereally
C γ-globulin does not protect contacts of short incubation
hepatitis
D Pale stools and dark urine are early features of infectious
hepatitis
E Chronic aggressive hepatitis is associated with antibodies
to smooth muscle and mitochondria and the Australia
antigen

143. Porto-systemic encephalopathy may be improved by:
A Lactulose
B Pyridostigmine
C High glucose intake
D Magnesium sulphate enemas
E Neomycin

144. Liver failure may be induced by:
A Barbiturate sedation
B Morphine sedation
C Diazepam sedation
D High protein diet
E High glucose diet
F Gastrointestinal haemorrhage

35

145. Haematemesis and melena in a patient with cirrhosis is likely to come from:
A Bleeding oesophageal varices
B Duodenal ulceration
C Gastric ulceration
D Abnormal clotting mechanisms
E Haemorrhoids
F Hepatoma
G Carcinoma of bile duct

146. Ascites:
A Is due to portal hypertension alone (in cirrhosis)
B Sometimes responds to bed rest
C Is associated with secondary hyperaldosteronism
D Is associated with inappropriate ADH secretion
E Can be detected radiologically
F May be the presenting feature of constrictive pericarditis

147. Haemochromatosis:
A Is transmitted by a recessive gene
B Is best treated by venesection
C Is best treated with desferrioxamine
D Predisposes to chronic active hepatitis
E Predisposes to hepatoma
F Is associated with a high iron binding capacity which is fully saturated

148. Which of the following are true:
A Rosette formation on histology is typical of chronic aggressive but not chronic persistent hepatitis
B Schistosomiasis causes cirrhosis
C Cardiac cirrhosis is characterised by nodular hyperplasia
D Hepatocellular failure may follow phenacetin poisoning
E Halothane jaundice occurs 1−2 weeks after first exposure

149. Cholestatic jaundice may result from therapy with:
 A Erythromycin stearate
 B Nitrofurantoin
 C Chlorpromazine
 D Lincomycin
 E Clindamycin
 F Primaquine
 G Testosterone proprionate
 H Phenacetin

150. Haemolytic jaundice may result from therapy with:
 A Erythromycin stearate
 B Nitrofurantoin
 C Chlorpromazine
 D Methyldopa
 E Primaquine
 F Testosterone proprionate
 G Phenacetin

GASTROENTEROLOGY

151. Gluten sensitive enteropathy:
 A May present in middle age
 B Occurs in families
 C Is associated with erythema annulare
 D Is associated with pemphigus vulgaris
 E Is associated with dermatitis herpetiformis
 F Is associated with psoriasis
 G Is associated with small bowel lymphoma

152. **Which of the following are true:**
 A Floculation of barium is the cardinal feature of steatorrhea
 B The degree of villous atrophy in gluten sensitivity correlates approximately with prognosis
 C Tropical sprue is caused by *Giardia lamblia*
 D Normal faecal fat excretion is up to 3 g/day
 E Lactase deficiency responds to withdrawal of milk from the diet

153. **Which of the following occur with ulcerative colitis:**
 A Erythema nodosum
 B Anterior uveitis
 C Arthritis affecting the ankles
 D Colonic dilatation
 E Rose thorn ulcers on barium enema

154. **Of the following which are the two most common hepatic complications of ulcerative colitis:**
 A Pericholangitis
 B Chronic aggressive hepatitis
 C Carcinoma of the bile duct
 D Sclerosing cholangitis
 E Fatty infiltration

155. **In ulcerative colitis:**
 A Oral ulceration may occur
 B Salazopyrine reduces relapse rate
 C A typical cobblestone appearance is seen on X-ray
 D Ankylosing spondylitis occurs more commonly
 E Prednisolone in large doses is required to prevent relapses
 F The rectum is involved in 90% of patients

38

156. **Which of the following are associated more with Crohn's disease than ulcerative colitis:**
 A Skip lesions on barium meal
 B Involvement of the colonic mucosa
 C Perianal inflammation
 D Acute toxic dilation of the ileum
 E Abdominal pain
 F Stricture formation

157. **Which of the following definitely accelerate healing of gastric ulcers:**
 A Antacids in gel form
 B Bed rest at home
 C Bed rest in hospital
 D Stopping smoking
 E Losing weight
 F Stopping alcohol
 G Sodium carbenoxalone (Biogastrone)
 H H_2 receptor blockade

158. **Which statements are true:**
 A Bleeding from colonic diverticula may be catastrophic
 B About half of haematemeses are from gastric ulcers
 C The most common cause of rectal bleeding is carcinoma of the colon
 D A blood urea of 140 mg% (23 mmol/litre) following haematemesis denotes previous renal disease
 E Ischaemic colitis involves mainly the hepatic flexure and transverse colon
 F Whipple's disease is characterised by typical granulomas seen on jejunal biopsy

159. **In the Zollinger–Ellison syndrome:**
 A Recurrent gastric ulceration typically occurs
 B A pancreatic gastrin secreting adenoma is usually present
 C The volume of gastric juice is increased to 3–4 litres/day
 D The tumour is malignant in over 50% of cases
 E There may be adenomas in other endocrine glands

160. **The following are features of chronic bronchitis:**
 A FEV/FVC ratio often less than 60%
 B Productive cough for 1 month for 2 consecutive years
 C Improves on stopping smoking
 D Mucolytic agents improve respiratory function
 E α_1-antitrypsin deficiency
 F The chest X-ray is rarely normal

161. **In status asthmaticus which of the following are true:**
 A Corticosteroids in large doses may cause increase in airways obstruction
 B β_2 stimulant drugs may be effective
 C $PaCO_2$ may be reduced
 D $PaCO_2$ may be raised
 E PaO_2 may be reduced
 F Disodium cromoglycate should be given in high doses
 G Sedation is potentially lethal

162. **Which of the following are typically complicated by lung abscess formation:**
 A *Mycoplasma pneumoniae* infection
 B Klebsiella pneumonia
 C Pulmonary embolism
 D Staphylococcal pneumonia
 E *Haemophilus influenzae* pneumonia
 F Pneumothorax

163. **Which of the following usually contraindicate surgical resection of bronchial carcinoma:**
 A FEV of less than 1 litre
 B Raised diaphragm with paradoxical movement
 C Metastases
 D Hoarseness of the voice
 E Multiple haemoptyses
 F Ectopic ACTH secretion

40

164. Bronchial carcinoma may be complicated by:
 A Cerebellar atrophy
 B Megaloblastic anaemia
 C Achilles tendinitis
 D ADH secretion usually from squamous cell carcinomas
 E Hypercalcaemia without bone secondary deposits
 F Pulmonary osteoarthropathy
 G Keratoderma blenorrhagica

165. In sarcoid which of the following occur:
 A Erythema marginatum
 B Hypercalcaemia which responds to steroids
 C Subperiostial erosion of phalanges
 D Diabetes mellitus
 E Diabetes insipidus

166. Which of the following statements are correct:
 A The hepatitis of rifampicin is usually mild
 B Ethionamide causes visual field defects
 C Ethambutol is hepatotoxic
 D INAH peripheral neuropathy may be reversed by Vitamin B_6
 E Streptomycin causes deafness if renal function is poor
 F Streptomycin is nephrotoxic

167. Episodic dyspnoea in a young woman of 30 years is likely to be due to pulmonary embolism if:
 A She takes the pill
 B Gallop rhythm is present on examination
 C She has fainting episodes with the attacks
 and is unlikely if:
 D There are no abnormal chest signs
 E The chest X-ray is normal
 F Blood gases are normal between attacks

168. **Patients with a spontaneous pneumothorax usually:**
 A Are overweight
 B Have severe dyspnoea at the onset
 C Have severe pain at the onset
 D Show increased movement of the chest on the affected side
 E Require intercostal drainage if more than 20% of the total lung field is collapsed
 F Improve spontaneously with resorption of the pneumothorax

169. **Which of the following are features of cryptogenic fibrosing alveolitis:**
 A Clubbing
 B Patchy fibrosis sometimes with tracheal deviation
 C Central cyanosis
 D Normal PaO_2 with reduced $PaCO_2$
 E Reduced FVC
 F Crepitations in the lower and mid zones

170. **Which of the following are true:**
 A Radioisotope perfusion lung scanning can distinguish embolism from infection
 B Lung scanning is a useful technique in the diagnosis of pulmonary embolism
 C Asbestosis predisposes to mesothelioma formation
 D Farmer's lung is a precipitin mediated reaction
 E Linear atelectasis is a feature of pulmonary embolism and systemic lupus erythematosus
 F Psittacosis is known as bird fancier's lung
 G Paragonamiasis is known as bird fancier's lung

171. **Known risk factors in the development of ischaemic heart disease are:**
 A Diabetes mellitus
 B Cigarette smoking
 C Type IV hyperlipidaemia
 D Heredity
 E Hypertension

172. **Following myocardial infarction:**
 A The mortality from sudden death is about 25%
 B Overall mortality is reduced if anticoagulants are given
 C Dopamine may reverse the hypotension of shock
 D Lignocaine is the treatment of choice for atrial ectopics
 E Wenckebach phenomenon is diagnosed by finding a prolonged PR interval on ECG
 F A pansystolic apical murmur suggests papillary muscle dysfunction
 G Cardiac aneurysm is suggested by persistent ST elevation

173. **Dressler's post-myocardial infarction syndrome is characterised by:**
 A Smooth muscle antibodies
 B Pericardial friction
 C Onset within 48 hours after infarction
 D Pleural effusion
 E Rapid response to steroids

174. **Which of the following exclude myocardial infarction:**
 A Normal ECG
 B No rise in the SGOT
 C Pain lasting less than 20 min
 D No radiation to the neck
 E No radiation to the arms

43

175. Which of the following statements are true:
 A Atrial fibrillation causes an irregular ventricular rhythm
 B Atrial flutter causes an irregular ventricular rhythm
 C In heart block after infarction the prognosis is better with inferior infarction than anterior infarction
 D Epilepsy may be the presenting feature of complete heart block
 E The 3rd heart sound is heard just before the 1st sound

176. In patients with suspected rheumatic fever:
 A *Streptococcus viridans* is often grown from nose or throat culture
 B Erythema nodosum is a major diagnostic criterion
 C Chorea is a major diagnostic criterion
 D Joint pains tend to be migratory mainly in large joints and exquisitely tender
 E Constrictive pericarditis is a recognised complication
 F The PR interval is typically prolonged

177. The 'opening snap' of mitral stenosis:
 A Denotes valve mobility
 B Disappears if atrial fibrillation occurs
 C Is usually best heard at the apex
 D Replaces the third heart sound
 E Is really a 'closing snap'

178. If mitral stenosis is present in a pregnant woman she:
 A Is in greatest danger in the 2nd trimester
 B Should be delivered by Caesarian section
 C May be symptom free after delivery
 D Should be anticoagulated to prevent venous thrombosis and pulmonary embolism
 E Will require prophylactic digoxin and diuretics before the 2nd trimester

44

179. **Mitral regurgitation is associated with:**
 A Marfan's syndrome
 B Ankylosing spondylitis
 C Hypertensive heart disease
 D Cardiomyopathy
 E Thyrotoxicosis
 F Myocardial infarction
 G Syphylitic carditis

180. **Which of the following are true of the effect of maternal rubella on the fetus:**
 A It is most dangerous in the 2nd trimester
 B It may cause ASD, VSD or patent ductus arteriosus
 C It may cause cerebellar degeneration
 D It may cause deafness
 E It may cause talipes equino-varus

181. **In aortic stenosis:**
 A There is often a previous history of syphilis
 B Fainting attacks may occur
 C Sudden death may occur
 D Angina is a common symptom
 E A cardiac thrill is uncommon
 F The second sound is quiet

182. **An ostium-primum atrial septal defect:**
 A Is more common than an ostium secundum defect
 B May be associated with a VSD
 C Produces right axis deviation
 D Produces left axis deviation
 E The main QRS axis is normal
 F Is more likely to become infected

45

183. **Which of the following are recognised associations of a ventricular septal defect:**
 A Atrial fibrillation
 B Infective endocarditis
 C Mongolism
 D Collapsing pulse
 E Wide fixed splitting of the second sound

184. **Fallot's tetralogy:**
 A Is the most common congenital heart disorder
 B May present with syncope and squatting
 C Is complicated by cerebral abscess formation
 D Is associated with paroxysmal emboli
 E Is not always associated with cyanosis in the neonate

185. **The diagnosis of infective endocarditis is supported by:**
 A Microscopic haematuria
 B Rose spots
 C Reduced complement levels
 D Antigen–antibody complexes in the serum
 E Culture of β-haemolytic streptococci from the throat
 F Osler's nodes
 G Conjunctival oedema

186. **Pericarditis may be a feature of:**
 A Uraemia
 B Coxsackie B infection
 C Herpes simplex infection
 D Systemic lupus erythematosus
 E Myocardial infarction
 F Bronchial carcinoma

187. In constrictive pericarditis:
 A Orthopnoea occurs early in the disease
 B Ascites occurs after ankle oedema
 C Fatigue is an early feature
 D Cannon waves are present in the JVP
 E Pericardial friction rub is often present
 F Calcification is not always present on the PA chest film
 but may be seen on the lateral X-ray

188. Uncontrolled hypertension increases the risk of:
 A Early death
 B Diabetes mellitus
 C Myocardial infarction
 D Pulmonary embolism
 E Subdural haemorrhage
 F Confusional state

189. All patients with hypertension require:
 A An IVP
 B An MSU
 C An ECG
 D A CXR
 E A 24 hour urine protein estimation
 F A VMA estimation
 G An estimation of cortisol diurnal variation

190. Which of the following are true:
 A Rib notching is seen on the upper rib border in aortic
 coarctation
 B Diazoxide by mouth or injection is used to control
 malignant (accelerated) hypertension
 C Accelerated hypertension is diagnosed by the occurrence
 of rapidly progressive cardiac failure
 D Hydrallazine acts mainly on the vasomotor centre
 E Reserpine acts mainly on the vasomotor centre
 F Hypokalaemia and alkalosis in hypertension suggest
 Cushing's or Conn's syndrome

191. Intermittent claudication:
 A Is associated with reduced life expectancy
 B Is relieved by α-receptor blocking agents
 C Is improved by graded walking exercises
 D Occurs in association with types III and IV hyper-lipidaemia

192. Which of the following are associated with Raynaud's phenomenon:
 A Colour changes in the order of white, red and blue
 B Phaeochromocytoma
 C Carcinoid syndrome
 D Methyldopa
 E Levodopa
 F Scleroderma
 G Chagas disease
 H Vibrating tools

DERMATOLOGY

193. The following are characteristic of psoriasis:
 A Silver scales
 B Wickham's striae
 C Koebner's phenomenon
 D Mucosal lesions
 E Pruritus

194. The following characterise lichen planus:
 A Silver scales
 B Wickham's striae
 C Koebner's phenomenon
 D Mucosal lesions
 E Pruritus

195. Which of the following are associated with arthritis:
 A Pityriasis rosea
 B Erythema marginatum
 C Keratoderma blenorrhagica
 D Lichen planus
 E Psoriasis

196. Candidiasis may complicate:
 A Diabetes mellitus
 B Diabetes insipidus
 C Hypoparathyroidism
 D Pseudo-hypoparathyroidism
 E Hyperthyroidism
 F Hodgkin's disease

197. Erythema nodosum occurs with:
 A Leprosy
 B Schistosomiasis
 C Toxoplasmosis
 D Lincomycin therapy
 E Gentamicin therapy
 F Rheumatic fever
 G Sarcoid

198. Lesions around the mouth are characteristically seen in:
 A Sarcoidosis
 B Dermatomyositis
 C Hereditary haemorrhagic telangiectasia
 D Crigler–Najjar syndrome
 E Peutz–Jegher syndrome
 F Herpes simplex infection

49

199. **Mucosal ulceration occurs in:**
 A Infection with Coxsackie B virus
 B Pernicious anaemia
 C Behçet's syndrome
 D Chickenpox
 E Acute lymphatic leukaemia
 F Pemphigus vulgaris

200. **In pemphigoid:**
 A Mucosal ulceration is common
 B Nikolski's sign is positive
 C Underlying carcinoma may be present
 D Prognosis is very poor
 E Prednisolone may control the skin eruption

CASE STUDIES

CASE 1

A 66-year old woman presents with lethargy, fatigue and dyspnoea on effort. She had a well-maintained appetite and had not lost weight. She had had no pain. Physical examination was within normal limits.

On investigation, routine haematology gave the following findings: Hb, 8·2 g/dl; PCV, 26; MCV, 76; MCH, 24; MCHC, 29; ESR, 21; retics, 3%.

a What kind of anaemia is this?
b What further direct questions do you wish to ask her?
c What further investigations would you perform?
d Which of the following, given your present information, would form part of your immediate management: oral iron, parenteral iron; whole blood transfusion; B_{12} injections and/or oral folic acid; cimetidine?

CASE 2

A 60-year old woman is admitted to hospital with a 5 day history of the symptoms of a urinary tract infection and pain in the right loin and over the bladder. She has had a rigor and is now semi-concious, disorientated and aggressive. On clinical examination, she was dehydrated and hyperventilating but there were no focal signs and no evidence of heart failure. There was no past history of respiratory disease.

a What is the likeliest diagnosis of the underlying disease?
b What investigations do you think are the most important in the initial investigation of this patient?
c List the 6 key points you must consider in the management of this patient.

CASE 3

A 50-year old man was readmitted to hospital following a fourth episode in two years of loss of conciousness and aggressive confusion. There is no history of fits and no focal neurological lesion was described or cardiac dysrhythmia noted. He was cold and clammy initially but recovered spontaneously still showing no neurological signs. The skin was unusually smooth and he had only a light thin growth of body hair. His testicles were noted to be small.

a What was the immediate cause of his admission to hospital?
b What is this due to in his case?
c How would you set about confirming it clinically
 i using 3 main points from the history
 ii using 3 main signs on examination
 iii What investigations would you perform?

CASE 4

A 37-year old unemployed medical educationalist gives a 3 week history of intermittent shortness of breath and wheezing. He has just returned from a short stay in Nigeria. He has never smoked. On examination it is noticed that he is highly stressed. He was markedly dyspnoeic at rest and there was a generalised expiratory wheeze. There was no clubbing or cyanosis and no cardiac abnormality. Investigations were reported as follows: Hb, electrolytes, CXR and liver function tests all normal; WBC, 8200 with 10% eosinophils; ESR, 30 mm in 1 hour, blood urea 10 mmol/litre (60 mg/dl). Clinically he has asthma of late onset.

a What might spirometry show before and after bronchodilators?
b Give the important underlying disorders.
c How would you investigate him further in the first instance? Give 4 tests.
d How would you manage the presenting problem?

CASE 5

An 86-year-old farmworker presents as an emergency after waking with a cold, painful and numb right leg from the mid-thigh downwards. No movements are present below the knee. On examination the limb is cold, pale, numb, cyanosed and immobile. The pulse is 120/min and in sinus rhythm, and the blood pressure 100 mmHg systolic (the diastolic is unrecordable).

a What is the clinical diagnosis?
b What are the possible underlying causes?
c Enumerate 6 possible factors which may be considered in the immediate management of this patient and discuss their relative importance.
d The leg improves spontaneously in the next few hours. What would be your further management of this patient if his general health also improved at the same time?

CASE 6A

A 60-year old Administrative Medical Officer was noticed by his colleagues to be slowing up more than expected (for his age) and especially so in the last 9 months. A medical opinion was sought. He walked slowly into the clinic and appeared apathetic and unresponsive. There were no specific features in the history.

a What initial diagnoses run through your mind?
b How would you investigate him initially? Suggest 2 tests.
c What should you tell the Senior Administrative Medical Officer about this?

CASE 6B

The patient was not depressed but treatment with levodopa produced dramatic improvement. Patients with Parkinsonism can present without observable tremor and the diagnosis is easily missed unless it is kept in mind in the differential diagnosis of the 'inert' patient. Such patients often respond well to modern therapy.

d How does the addition of a dopa decarboxylase inhibitor to levodopa affect its efficacy?
e What other treatments are available for the treatment of Parkinsonism?

CASE 7

A 65-year old postman was admitted for treatment to a large painful varicose leg ulcer which had failed to heal with conventional treatment over the last 2 years and from which betahaemolytic streptococci had been isolated. The infection was first treated with oral sulphadimidine and finally responded to a course of penicillin G and the ulcer healed over the course of the next 3 weeks. Just before discharge the House Physician noticed that the patient appeared cyanosed. The patient did not feel short of breath and there was no history of chest trouble. There were no abnormal physical signs in the chest and the CXR appeared normal. He had never been a smoker.

a What do you feel is the most likely diagnosis and what other conditions would you consider?
b How would you investigate him?
c If you think treatment is indicated, what would you use, and how long would you continue it?

CASE 8

A 27-year old girl came to the clinic with a 2 month history of progressive weakness during which she had noticed that she was able to get on her bicycle to go to work but unable to get off it easily. Recently her jaw had tended to stay open towards the end of a conversation. On examination she had mild bilateral ptosis and held her jaw closed with the left hand whilst giving the later part of her history.

a What diagnoses have run through your mind in a rough order of probability?
b Name one investigation which can be performed in the clinic and which may give an immediate diagnosis.
c If positive, what drug treatment might you use in her initial treatment?
d Give four main differences between your diagnosis and the Eaton-Lambert syndrome.

55

CASE 9

A 23-year old previously fit amateur footballer went to bed early telling his wife that he thought he was getting 'flu'. She watched television late and when she got to bed found him to be confused and disorientated. The general practitioner who called half an hour later, found him stuporose, diagnosed acute meningitis, and admitted him forthwith to hospital. On admission apart from the reduced level of consciousness, the only abnormal sign was severe neck stiffness. Lumbar puncture was performed and the CSF was reported as showing a protein concentration of 200 mg/dl (20 g/litre), 240 polymorphs and 20 lymphocytes and a Gram stain film showed Gram-positive intracellular diplococci.

a What is the responsible organism?
b Should antibacterial chemotherapy be started before the results of bacterial culture are available?
c What is your initial treatment of choice? What would you suggest as best second-line therapy? Give appropriate doses, frequency and route.

CASE 10

A 43-year old man, a known hypertensive, presents with jaundice. The liver function tests show a bilirubin (total) of 19 mmol/litre (11 mg/dl), an alkaline phosphatase of 92 IU/litre (upper limit of normal range; 90), an APT (SGPT) of 31 (upper limit normal; 32) and urine which contained urobilingen. The blood count showed a haemoglobin of 9 g/dl and the film was normocytic and normochromic. The reticulocyte count was 7%.

a What kind of anaemia is this?
b What are the commoner causes of it and which are the likeliest in this man?
c What investigations would help to confirm your provisional diagnosis?

CASE 11

A 23-year old man presents with a two month history of nocturnal fever, lassitude and weight loss. On examination, he is found to have pallor and enlarged lymph nodes on the left side of his neck. The spleen was just palpable. Lymph node biopsy was reported as follows: Many Reed-Sternberg cells present with plentiful lymphocytes; There is no fibrosis.

a What is your diagnosis?
b What features given above will guide your prognosis?
c What features given above will guide your therapy?

CASE 12

A 50-year old patient previously fit, presented with a 'flu'-like illness for two days, followed by jaundice on the third day which had persisted for the next fortnight. He had noticed that his urine had appeared dark and his stools pale. On examination his liver was just palpable but not tender. The liver function tests showed a moderately raised serum bilirubin and alkaline phosphatase and an SGPT (APT) about 3 times the upper limit of the normal range.

a What abnormalities do you expect to find in the urine on standard ward testing?
b What are the 4 most likely diagnoses in order of probability given the above facts?
c What further investigations would you perform?

ANSWERS

PART ONE

Question	Answer	Question	Answer	Question	Answer
1	BDE	20	AD	39	CD
2	ACD	21	ABEF	40	AD
3	AD	22	CF	41	BCD
4	ABD	23	ABCDEF	42	ABD
5	BCE	24	AC	43	BC
6	AD	25	ABDEF	44	ABCFG
7	CD	26	BCDE	45	CD
8	BCDF	27	ACDF	46	CDEG
9	BE	28	BDE	47	AD
10	CDE	29	ACEF	48	ABC
11	ACDEF	30	ACD	49	ABCDE
12	BE	31	BDE	50	ACD
13	C	32	ABCF	51	BCD
14	ABE	33	BCE	52	ABC
15	ABDEF	34	ABE	53	CDE
16	BCDE	35	ADEF	54	ABG
17	ACEG	36	DEF	55	ABE
18	CD	37	B	56	CE
19	D	38	ACD	57	BCF

PART TWO

Question	Answer	Question	Answer	Question	Answer
58	CE	90	CDF	122	DE
59	DE	91	AB	123	ABCDE
60	ABE	92	BCE	124	ACDG
61	A	93	BCDE	125	BCEG
62	ABCDEF	94	BCDE	126	ACDF
63	ABCE	95	CE	127	BCE
64	–	96	ABD	128	BD
65	AE	97	ACDE	129	BC
66	ACDE	98	ABE	130	CD
67	ABCDG	99	BE	131	BCE
68	ABCDEFGH	100	BD	132	B
69	ABE	101	BDE	133	CD
70	CEF	102	ADE	134	AC
71	BDE	103	BE	135	AE
72	CD	104	CD	136	C
73	AC	105	BEG	137	ABD
74	–	106	ACDE	138	AB
75	ABD	107	BD	139	CDF
76	ACD	108	CE	140	ACE
77	BCE	109	ABCD	141	B
78	CE	110	ABE	142	BD
79	ABC	111	ACDE	143	ACDE
80	ABCDE	112	CD	144	ABDF
81	ACDEF	113	ACDEF	145	ABCD
82	ACD	114	ABCDE	146	BCEF
83	ADE	115	ACD	147	BE
84	BDE	116	CD	148	AD
85	ABD	117	BCE	149	BC
86	–	118	AD	150	DEG
87	ABCDE	119	AC	151	ABEG
88	BCD	120	CD	152	E
89	BDE	121	B	153	ABCD

Question	Answer	Question	Answer	Question	Answer
154	AE	170	BCDE	186	ABDEF
155	ABD	171	ABCDE	187	CF
156	ACEF	172	ACFG	188	ACF
157	CDGH	173	BDE	189	BCD
158	AB	174	—	190	EF
159	BDE	175	ABD	191	AD
160	AC	176	CDF	192	FH
161	BCDEG	177	A	193	A
162	BD	178	C	194	BCDE
163	ABCD	179	ACDF	195	BCE
164	AEF	180	BD	196	ACDF
165	BE	181	BCDF	197	ACFG
166	ADE	182	BDF	198	CEF
167	AB	183	BC	199	CDEF
168	CF	184	BCDE	200	CE
169	ACEF	185	ACDF		

ANSWERS TO CASE STUDIES

CASE 1

a 'Iron deficiency anaemia'

b Enquire about (i) any bleeding anywhere particularly from gut or vagina; (ii) drugs, especially analgesics; (iii) indigestion; (iv) change in bowel habit. Enquire about diet particularly in the elderly.

c Faeces for occult blood. Serum iron and total iron binding capacity. Sigmoidoscopy. If the results confirm the diagnosis of iron deficiency and there are not localising symptoms or signs, proceed to barium enema. If normal, proceed to barium swallow and meal.

d Oral iron

CASE 2

a Diabetes mellitus.

b Blood sugar. Blood urea and electrolytes. Urine for microscopy and bacteriology. Routine haematology including white cell differential. Arterial blood for acid—base status. Blood culture.

c Fluid balance. Method and dose of insulin. Diagnosis and treatment of precipitating cause. Serum potassium concentration and potassium balance. Aspiration of stomach. Acid—base status.

CASE 3

a Hypoglycaemia, possibly with hypoadrenalism.
b Pituitary failure.
c i Aggression is characteristic of hypoglycaemia. Reduced frequency of shaving. An increased tendency to feel the cold.
 ii The skin is fine and hairless. Look for bitemporal hemianopia. Small testicles.
 iii Serum cortisol with diurnal variation. Cortisol production rate. Serum thyroxine and TSH. Serum FSH/LH. Synacthen (tetracosactrin) test. X-ray the pituitary fossa.

N.B. Treatment should include parenteral cortisol (hydrocortisone) as well as glucose.

CASE 4

a A grossly reduced FEV1 (if he is capable of performing the test at all) e.g., $0\cdot5-1\cdot0$ litre in one second. The FVC is commonly much reduced and the vital capacity usually cannot be fully expelled because of the airways obstruction. After bronchodilators, there is usually considerable improvement toward normal.
b Pulmonary eosinophilia due to worms. Polyarteritis nodosa. Extrinsic allergic alveolitis. Aspergillosis. Stress.
c Urine for red cells. Stools for cysts, ova, worms. IVP and consider renal biopsy if PN is a reasonable possibility.
Testing of skin or bronchial hypersensitivity is unlikely to be helpful. (Chest X-ray has already been performed.)
d Intravenous hydrocortisone, B_2-agonist (e.g., salbutamol, terbutaline), aminophylline and fluids. High concentration oxygen (e.g., 40–50%). Antibacterial therapy may be necessary.

CASE 5

a Acute obstruction of the femoral artery.

b Embolism possibly from the left atrium with paroxysmal atrial fibrillation, and thrombosis.

c Keep the limb cool. Consider surgical disobliteration. Rest. Give oxygen in high concentration (possibly hyperbaric if available). Anticoagulate (with heparin by infusion and followed by oral anticoagulants). Infuse low molecular weight dextrans. Thrombolytic agents. Vasodilators.

d Continue conservative medical management. Mobilise early. Discharge as soon as possible if the limb remains viable and preferably off all treatment.

CASE 6A

a Depression. Senile dementia. Hypothyroidism. Parkinsonism. Sedative drug abuse.

b Thyroid function tests. Serum barbiturate.

c Nothing.

CASE 6B

d The addition of a dopa decarboxylase inhibitor tends to prevent the breakdown of administered levodopa to dopamine in the peripheral tissues and there is thus a reduction in the side effects due to the peripheral actions of levodopa metabolites (especially nausea and vomiting and to a lesser extent hypotension). The dose of levodopa is much reduced to obtain the same effect on the Parkinsonism.

e Anticholinergic drugs. Amantidine. Bromocryptine. Physiotherapy. Stereotactic surgery. Antidepressent drugs (excluding MAOI drugs) if necessary.

65

CASE 7

a Multiple pulmonary emboli is the most likely diagnosis. Polycythaemia rubra vera may be associated with leg ulcers. Methaemoglobinaemia may result from sulphonamide or phenacetin therapy.

b Recheck the CXR for attenuation of peripheral vessels — easily missed. Lung perfusion scan. Haemoglobin and PVC. Arterial blood gases of PaO_2. Blood spectroscopy for methaemoglobin.

c Heparin initially and Warfarin for 3 months. Polycythaemia rubra vera may require venesection; chemotherapy may also be used. Lifelong follow up is necessary. No treatment is required for methaemoglobinaemia in the absence of symptoms other than the removal of an identified cause; spontaneous recovery is the rule.

CASE 8

a Myasthenia gravis, hypokalaemia, hysteria, familial periodic paralysis, facio-scapular-humeral muscular dystrophy, Eaton-Lambert syndrome.

b Intravenous edrophonium (Tensilon) 10 mg should result in an immediate and dramatic reduction in muscular weakness in patients with myasthenia gravis.

c Pyridostigmine. Between 5 and 20 tablets (60 mg) may be required in one day divided into several doses per day (i.e. 300–1200 mg daily dose). Initial doses should be small and the dose gradually worked up. Overdose may give depolarisation block with weakness. An alternative is neostigmine one or two 15 mg tablets at a time. They need to be given more frequently than pyridostigmine because of their shorter duration of action.

d In the Eaton-Lambert syndrome the facial muscles are less affected than the limb muscles (especially the proximal muscles); muscle strength may initially be increased by repeated movements; there is no response to edrophonium; a carcinoma frequently of the bronchus, is usually identifiable.

CASE 9

a Pneumococcal meningitis. Acute meningitis.
b Yes. Even brief delay in starting effective therapy can result in increased morbidity and mortality.
c Benzyl-penicillin 12–20 megaunits intravenously per 24 hours in divided doses (6-hourly). Chloramphenicol 1 g 6-hourly initially.

CASE 10

a Haemolytic.
b Haemoglobinopathies, drug therapy, rhesus incompatibility, malaria, complication of leukaemia and autoimmune. This man has probably been treated with methyldopa.
c Direct Coomb's test is positive in haemolytic jaundice due to autoimmune disease and methyldopa therapy.

CASE 11

a Hodgkin's disease, clinically Stage IIIB.
b Though the lymphadenopathy is clinically confined to one region, the presence of a palpable spleen stages his disease as not less than Stage III.
 The presence of plentiful lymphocytes is a good prognostic feature.
c The staging of Hodgkin's disease determines therapy as well as prognosis. Patients with the staging of IIIB are now customarily treated with multiple chemotherapy and radiotherapy.

CASE 12

a The presence of bilirubin and urobilin in excess.

b Carcinoma of the head of the pancreas, obstruction of the bile duct by a gall stone, drug jaundice, infectious hepatitis.

c None of the history strongly suggests drug jaundice. If jaundice improves, infectious hepatitis, drugs or gall stones become likely and cholangiography should be performed to exclude stones. If obstructive jaundice persists, proceed to ultrasound and liver scan (to detect enlarged ducts), percutaneous cholangiography with arrangements to proceed to liver biopsy or laparotomy if necessary.